S0-BAT-835

IMAGES
of America

BERKELEY SPRINGS

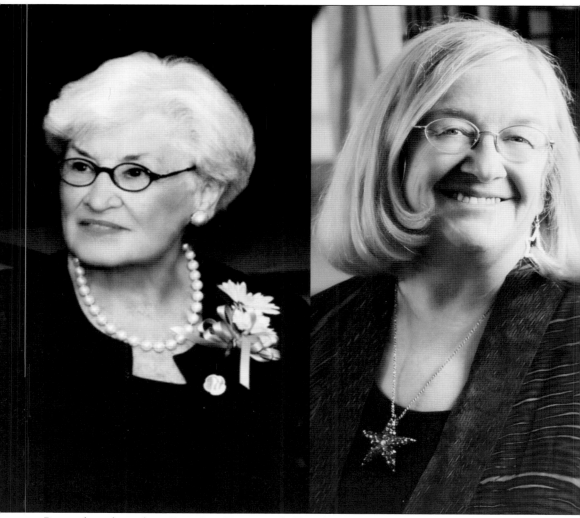

Pictured are the authors, Betty Lou Harmison (left) and Jeanne Mozier. Both are winners of the West Virginia History Hero award. (Left, courtesy of Slainte Images; right, courtesy of Bob Peak.)

ON THE COVER: Once the Season at the Springs ended in September, notable local women dressed up to come to the park. This trio of lovelies posed in the twig gazebo around 1911 included, from left to right, Beatrice Johnson, Odessa Mendenhall, and Mame Hunter. (Courtesy of the Museum of the Berkeley Springs.)

IMAGES
of America

BERKELEY SPRINGS

Jeanne Mozier and Betty Lou Harmison

ARCADIA
PUBLISHING

Copyright © 2011 by Jeanne Mozier and Betty Lou Harmison
ISBN 978-0-7385-8799-8

Published by Arcadia Publishing
Charleston, South Carolina

Printed in the United States of America

Library of Congress Control Number: 2011925868

For all general information, please contact Arcadia Publishing:
Telephone 843-853-2070
Fax 843-853-0044
E-mail sales@arcadiapublishing.com
For customer service and orders:
Toll-Free 1-888-313-2665

Visit us on the Internet at www.arcadiapublishing.com

To all those who took and saved the photographs
that allow us an intimate peek at our past

CONTENTS

ACKNOWLEDGMENTS

Most of the images in this book come from the rich and extensive collection of Betty Lou Harmison and the photographs held in trust by the Museum of the Berkeley Springs; images from these two sources are not credited individually. The Morgan County Historical Society (MCHS)—in particular, Nancy Largent—was generous in opening the MCHS collection to us. Dozens of other people in Berkeley Springs made this book possible by sharing their treasured photographs and even more precious stories. We owe special thanks to Teresa McBee and Linda Swaim Buzzerd for the time they spent unearthing some of the most endearing images in the book and to Dawn Childs who single-handedly collected most of the farm photographs. We appreciate being able to check our own extensive and original research against the earlier efforts of local historians and collectors, including Fred Newbraugh, Katherine Hunter, and Jessie Hunter, as well as the ongoing insightful and thorough work of another West Virginia History Hero, John Douglas, and the *Morgan Messenger* newspaper that he edits. Most of all, we acknowledge with heartfelt sincerity and the greatest of pleasure the undeniable truth that the book could not have been done by either of us working alone.

INTRODUCTION

The warm mineral springs that are the mark of Berkeley Springs' destiny as a spa town run more than a mile deep and millennia long in the geology of the area. They emerge in a cluster at the base of a steep sandstone ridge in the narrow northern section of a valley seven miles south of the Potomac River. Enjoyed by tribal visitors for thousands of years, they are the waters George Washington called "fam'd warm springs."

In 18th century America, towns were founded around harbors, along rivers, at gaps in mountains, or at the intersection of major trails and roads, but not Berkeley Springs. It was settled and grew into a town because of its thermal springs. In this tiny mountain enclave, today known around the world for its spas and art, life has always been about the water.

During the 1740s, the eastern edge of the Appalachians, including the area around the springs, was frontier country. Native tribes passed on information about the warm healing waters to early travelers—mostly missionaries, explorers, and adventurers. Permanent settlers' homes were limited to the occasional rough cabin along Sleepy Creek.

All the land in the region belonged to Thomas Lord Fairfax, who was disinclined to sell it. As early as 1747, Fairfax was concerned about squatters on his land but indicated a willingness to set up a town around the springs to serve those who came to take the waters. Although nothing official happened for nearly 30 years, a town of sorts organized itself around the springs by 1750. By the following decade, notable early visitors, like Charles Carroll and Horatio Gates, were squatters, building summer cabins on land they did not own. Originally, George Washington complained "lodging may be had on no terms but building them." During his later visits with his family in the 1760s, the Washingtons were able to stay in houses, including that of his friend James Mercer. They also spent time socializing with Lord Fairfax and his nephews, who had cottages at the springs. There are historic reports of racetracks, gambling, and houses of ill repute. Francis Asbury, America's first Methodist bishop, condemned Berkeley Springs as "that seat of sin."

In 1776, the Virginia Legislature responded to a petition from more than 200 individuals who wanted a town around the springs. They established Bath, still the official name of the municipality. No matter what the law says, from 1772 to the present, the town area has been known to the world as Berkeley Springs, the name of its waters and its postal address.

A Victorian newspaper editor saw the area around the springs as not only having two names, Berkeley Springs and Bath, and two seasons, with and without visitors, but also as two distinct places. "It can now be called Berkeley Springs. We are getting tony and putting on our usual summer style. Go away Bath. We don't know you now." The close of season in fall reversed the image: "Hotel band left Sunday. Soon it will be Bath again."

In the summer of 1777, more than 100 lots were laid out and sold at auction, the revenue going to Lord Fairfax, who kept a spring and a few lots for himself and his nephews. George Washington purchased two lots, and other colonial notables and Washington family members were sprinkled among the more than 70 original landowners. Nearly a dozen claimed multiple

honorifics, as members of the Continental Congress, signers of the Declaration of Independence and Constitution, and Revolutionary War generals. Several blocks around the springs and park have served as the commercial and official center of the area for more than two centuries. The main streets remain Fairfax and Washington, while others bear strikingly period names, including Congress, Independence, Union, and Bath.

From the 1740s to the early 20th century, Berkeley Springs was a popular summer resort with a small permanent population and mostly wooden structures. Several times through the centuries, the smell of smoke and charred wood changed the course of commerce and compelled downtown redevelopment.

The first destructive fire was in 1844, and it destroyed many 18th-century buildings. The construction that followed included the 300-room Berkeley Springs Hotel, the second Morgan County Courthouse, and the first Methodist church, both on their current sites. In 1898, another major fire destroyed the Berkeley Springs Hotel, and three years later, fire took the Fairfax Inn, which was on the block facing the park. The tanneries that dominated downtown in the Victorian era and were in major conflict with the hotel industry of the time also burned or were razed by the turn of the 20th century. A major fire in 1974 destroyed the south side of east Fairfax Street, including the Washington Hotel, the last of the grand resort hotels. In 2006, what was hopefully the last major fire destroyed the Morgan County Courthouse, which has since been replaced.

Wars have been another agent of change for Berkeley Springs. This included the Civil War, which altered its address from Virginia to West Virginia and saw its summer population change from southern planters to northern industrialists. By the end of World War I, the population of rich cottagers and permanent summer guests was severely reduced. Berkeley Springs began to develop more as a local community. World War II ended the extensive tomato industry and began patterns of out-migration that did not reverse until the late 1970s.

By 1880, many of the original town lots held large summer cottages that were razed throughout the 20th century to construct modern residences, businesses, and churches. Although Fairfax and Washington Streets have long been commercial areas, most of the current structures housing shops and restaurants date to a building boom in the early 20th century.

In spite of the astonishment that George Washington would experience were he to return today to his favorite getaway spot, he would recognize several familiar aspects. Geography still finds twin mountain ridges defining a north-south flow of activity. The Potomac River continues to mark the northern boundary of the county with its twists and turns. His favorite overlook now includes highways, railroads, and four states instead of three, but the vista still features the bends of the Potomac and the cascading mountain tops of the Appalachians to the west. The springs continue to flow at a steady rate and temperature on public land in the heart of town, although they are now owned and operated as Berkeley Springs State Park. Most of all, the people remain welcoming, inventive, and protective of their most precious resource—the water.

One

OVERLOOKS

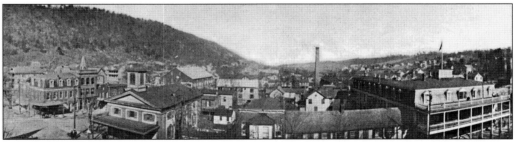

It takes the right topography to create overlooks. Berkeley Springs has two primary locations that benefit from the perfect alignment of ridge, mountain, and valley. The Potomac River cuts through the mountains, providing panoramic views. The town itself is situated in a narrow valley bound steeply on the west by a sandstone ridge, from which the warm springs flow. The c. 1905 panoramic image is dated by the second courthouse (center left) and the Dunn Hotel on the right.

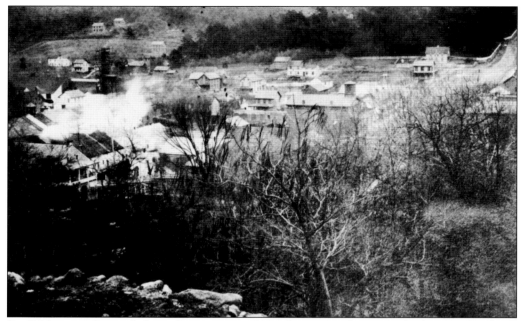

Scaffolding on the stack dates this image to 1888, when DeFord Tannery built a 103-foot brick chimney, the highest in the state. Looking east from Warm Springs Ridge, the Florence Hotel is visible, with its walkway leading to the St. Elmo Hotel. Just up the hill is the Clifton House. Farther east along a dirt Fairfax Street is the second courthouse.

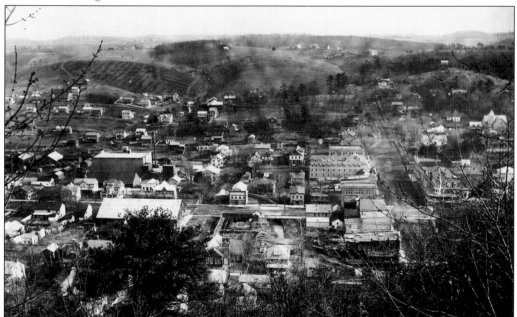

The large tannery is gone, leaving a hole in the ground. Across Washington Street is the cold-storage building, which was constructed in 1911 and was the most advanced in the country. By 1931, it had a capacity of 50,000 barrels of apples. A broad Fairfax Street running uphill has no median, dating this photograph to around 1915.

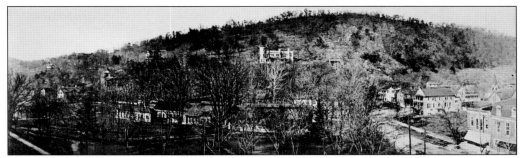

Warm Springs Ridge, featuring Berkeley Castle, defines the view to the west. Covered bathhouses extend along Warm Spring Run in a tree-filled version of today's Berkeley Springs State Park. The open gap in the buildings to the right, where the Fairfax Inn stood, dates the image to around 1910.

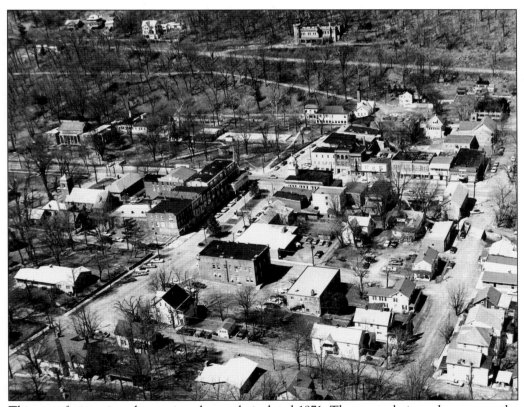

This west-facing view showcasing the castle is dated 1971. The most obvious changes are the disappearance of the extensive covered bathhouses in the park and the presence of a large hotel on the south end. Commercial buildings fill the gap left by the 1901 burning of the Fairfax Inn.

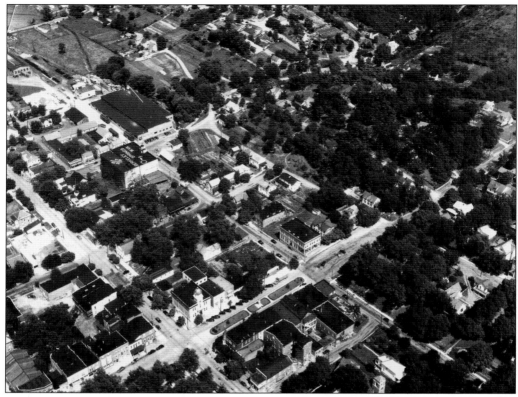

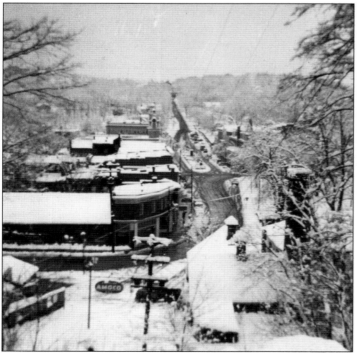

Buildings appearing and vanishing date this image to around 1947. The lettering on the roof of the cold-storage building is the longitude and altitude for Berkeley Springs. There is also a directional for Potomac Airpark along the river, a commonplace navigational tool for pilots in pre-instrument days.

Located on the original lot A at the entrance of the park, this building was constructed in 1922 as a car storage garage. Previous occupants of the lot included the county's first courthouse, the St. Elmo Hotel, and the Fairfax Inn Annex. By 1912, fire cleared the site.

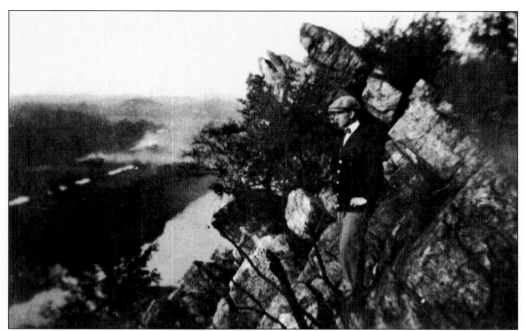

Lovers Leap was a favorite location for picnics and parties in Victorian times. It was enjoyed by locals, summer people, and hotel guests. Decades later, this Henry Ruppenthal image of Lovers Leap was made into a popular postcard (below). The rock formation marks the northernmost edge of Warm Springs Ridge, and there is a view looking east down the Potomac. Three states are visible from left to right—Maryland, Pennsylvania, and West Virginia. Baltimore & Ohio (B&O) Railroad tracks and sand mine structures are in the foreground. The rock formation is now part of the area mined by US Silica. It has been closed to the public since the mid-1980s. (Above, courtesy of McBee family.)

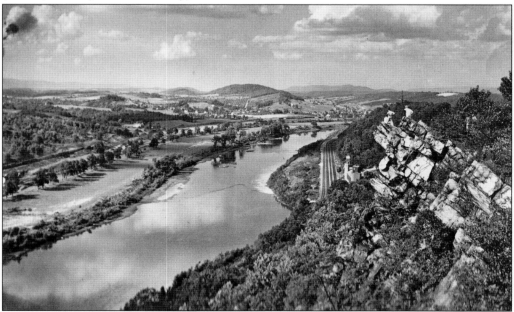

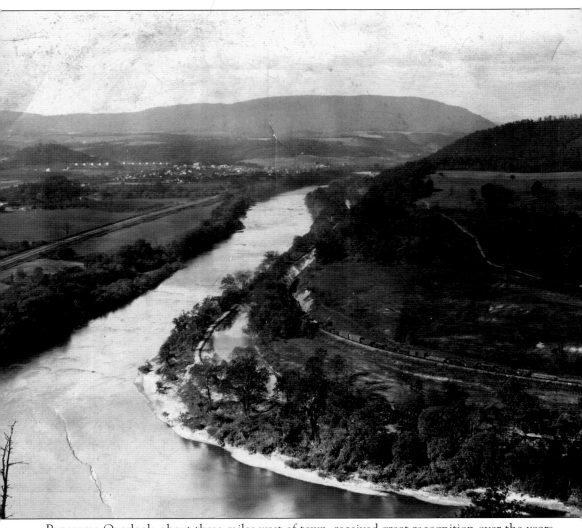

Panorama Overlook, about three miles west of town, received great recognition over the years, including it being dubbed the "Switzerland view of America" by *National Geographic*. The history of American transportation is contained in the view. The Potomac River, the Chesapeake and Ohio (C&O) Canal on the northern (Maryland) side, and the B&O Railroad on the southern (West Virginia) side were all important ways to move goods and people at various times in history. The scenic overlook marks the spot where Cacapon Mountain plunges nearly 1,000 feet into the river. For most of the past century, it has been reachable by Highway WV9 heading west.

Two

TAKING THE WATERS

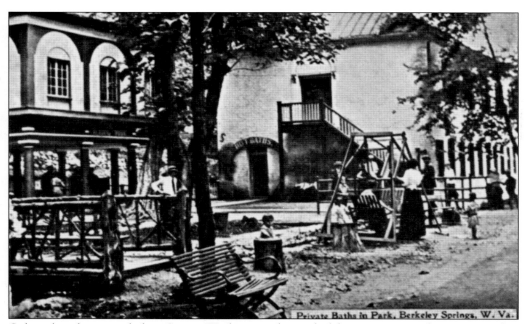

Colonial explorers, including George Washington, learned of the warm springs from native tribes who revered the waters. Since the 1740s, the area around the springs has been public ground, known variously as Bath Square, the Grove, and Berkeley Springs State Park. Whatever the name, bathhouses and walkways always marked the scene.

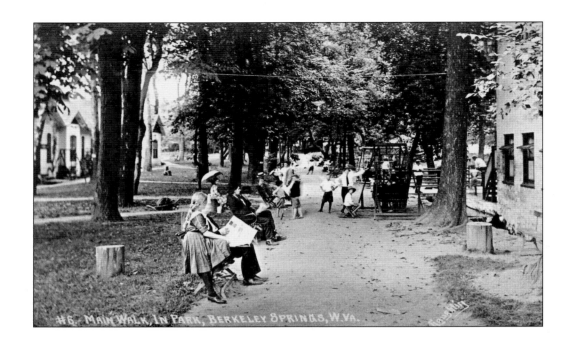

In 1910, the state of West Virginia reclaimed the lease on the springs after some years of decline. The following spring, workers began to clean up the Grove, putting in new benches and installing electric lights. The main walkway along the western edge of the park area where the springs emerge from the ground was lined on both sides with bathhouses. In these postcards, the view above is looking south; the one below is looking north.

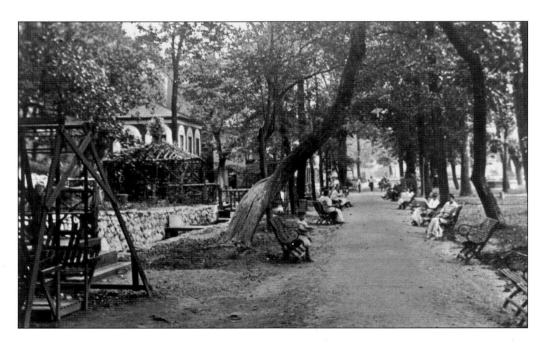

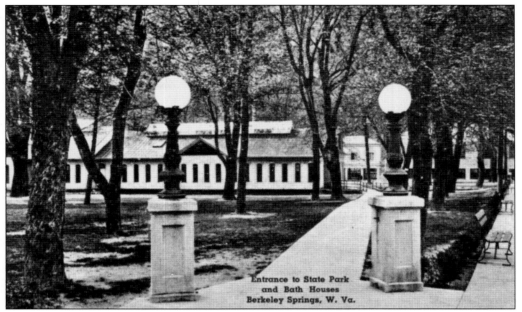

Entrance to State Park
and Bath Houses
Berkeley Springs, W. Va.

This postcard dated 1939 shows the large cement columns with iron posts and electric lights that were erected at the Washington Street entrance to Berkeley Springs State Park in 1915. They were replaced by a trickle, stone fountain in 1963 as part of the state centennial. Prior to 1881, no part of the park fronted on Washington Street, and the main entrance was from Wilkes Street on the park's northwest corner.

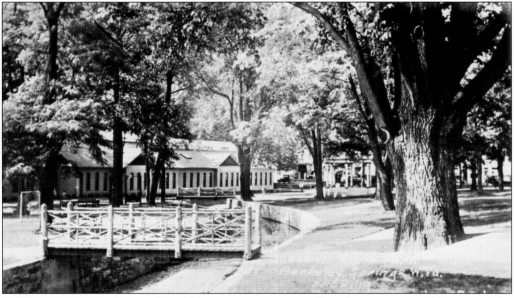

Three generations of covered bathhouses were constructed in the same general location. The latest incarnation, shown here, was designed and built in 1889 by longtime bath keeper Henry Harrison Hunter. The rustic bridge across Warm Springs Run was nearly washed away in the flood of 1936, the year after this photograph was taken. The bathhouses were razed between 1948 and 1949.

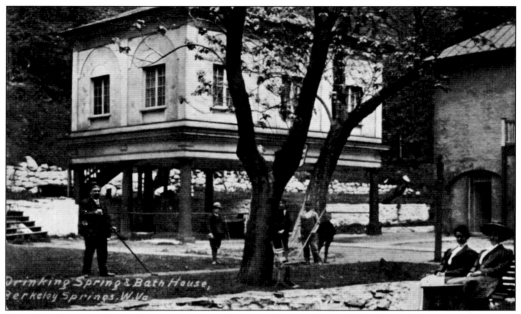

The Gentlemen's Springhouse stands unchanged from at least 1853. The public fountain stood in the pavilion since the 1780s. It fulfilled the Virginia House of Burgesses' bequest in 1776 that the springs would always be freely available to the public. Over the years, an employee would dip the water for people to drink. In 1925, the person was replaced by individual drinking cups. The room upstairs served many purposes, starting as a gentlemen's lounge where men watched as 19th-century mothers paraded their marriageable daughters along the walkways.

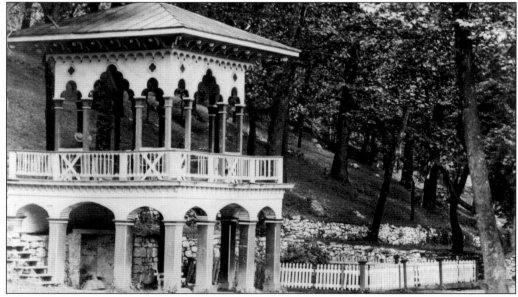

The pagoda was built over the Ladies Spring on the south end of the park about 1853 and torn down in 1918. It was regularly used during the season as a bandstand. Described as "bursting forth from rock in the form of a cone," the Ladies Spring remains a major water supply for the town system.

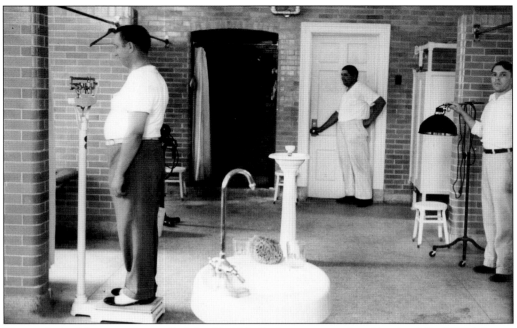

The main bathhouse, often called the Turkish Baths, was completed in the fall of 1929. It was built at the south end of the park on newly acquired land that once held summer cottages and the Berkeley Springs Hotel. Treatments were and still are provided in gender-segregated areas and include baths, steams, and massages. The view above of the interior of the men's section includes Reid Johnson on the right. He was head masseur during the 1940s and 1950s.

Bricks for the Victorian covered pool and bathhouse were made at the north end of town. The men's bathhouse was constructed in 1889; the ladies' was constructed the previous year. Each gender had a swimming pool, as well as private baths and showers. The wall was removed between the two pools in 1921, although the sexes had been bathing together on and off for more than a decade, always to complaints of vulgarity. The interior of the men's pool with its skylights is pictured in this 1930 postcard (below).

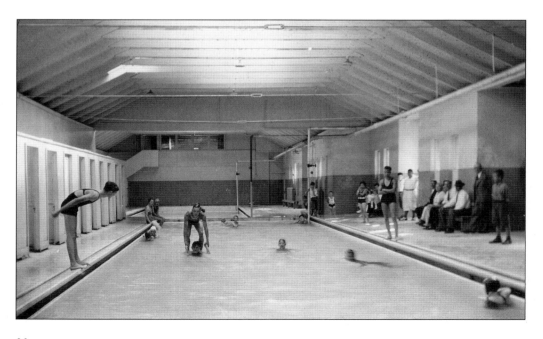

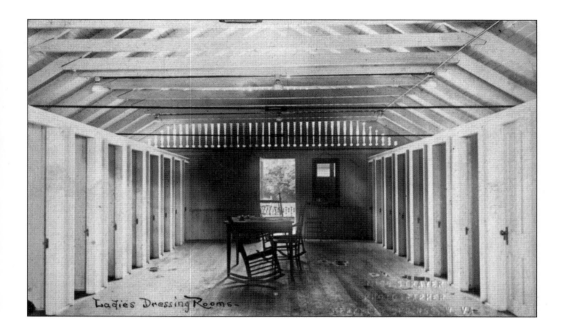

Ladies Dressing Rooms

By 1915, the covered bathhouse had its natural brick exterior painted. This south end of the long structure housed the ladies' pool. On the second floor, the ladies' dressing room opened onto a porch. Local photographer Eva Strayer captured these images in postcards before she left in 1917.

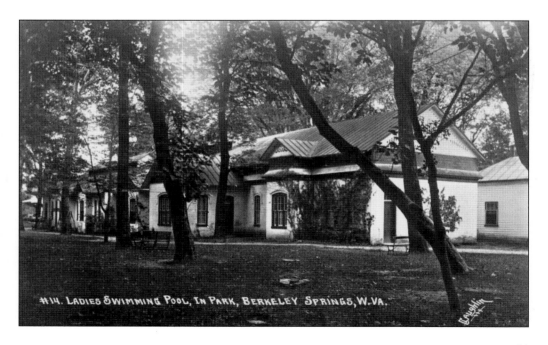

#14. LADIES SWIMMING POOL, IN PARK, BERKELEY SPRINGS, W.VA.

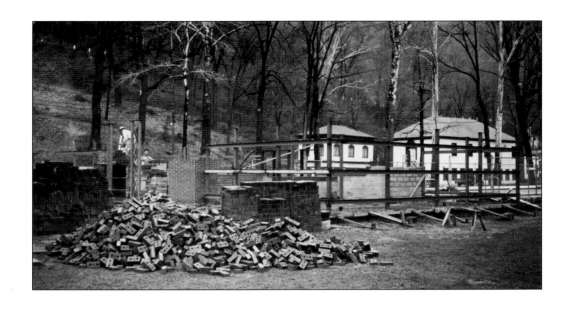

In 1948 and 1949, the Victorian covered baths, built by Henry Harrison Hunter, were demolished to install a modern outdoor swimming pool, one of the first in West Virginia. The pool is filled every season with water from the same Fairfax Spring that once was used in the covered baths. The pool opened in June 1951. Dressing quarters with showers were constructed for men and women four years later.

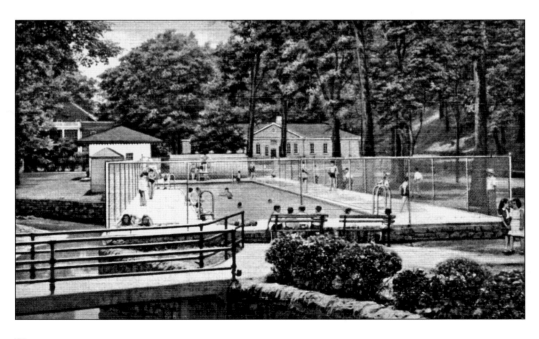

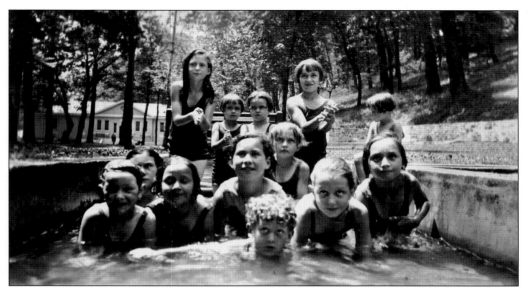

Generations of local kids learned to swim in the overflow channels filled with spring water. Among the children in this early-1930s photograph was June Heare, whose father, Gracen, was park superintendent. Her sister Gertrude later married the son of another park superintendent.

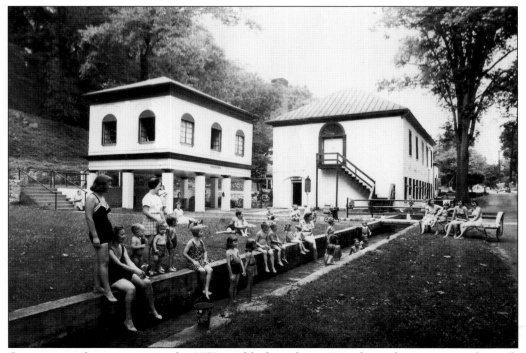

On summer afternoons, as in the 1950s and before, the springs channel remains popular with local mothers and children. The large spring behind the two-story Roman Bathhouse was fenced off but is not yet covered.

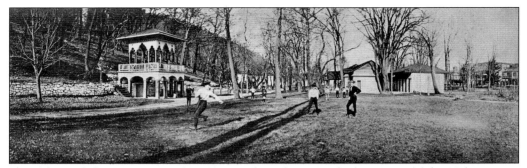

Once the Berkeley Springs Hotel ruins were cleared away at the beginning of the 20th century, the south end of the park was opened up for local play. Most of the large trees were gone, having been damaged by the 1898 hotel fire. This postcard scene of boys playing dates to 1905. The second courthouse is in the background to the right. Bathhouses dominate the picture.

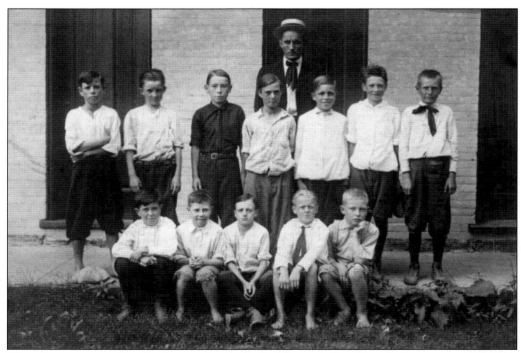

These boys are posed by the former shower baths. This was the oldest park structure, dating to 1784. By 1931, it was converted to an office and restrooms, as it remains today.

24

The Washington Elm provided a perfect background for local young women. The bridge over Warm Springs Run, on which they are standing, has been replaced by one sturdy enough for automobiles driving to the Country Inn and park bathhouse. (Courtesy of McBee family.)

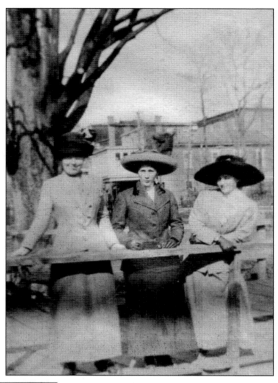

It was popular entertainment around the turn of the 20th century for young men to meet the train and look over the "summer girls" who came to Berkeley Springs to spend the day. In the park, girls strolled and bands played on a Sunday afternoon. (Courtesy of Morgan County Historical Society.)

Viola Widmyer married Lee "Mutt" Wash, who was the town barber. Her father owned a general store across Washington Street from the park. Once married, Viola was famous for her hats and reportedly never seen without one. (Courtesy of McBee family.)

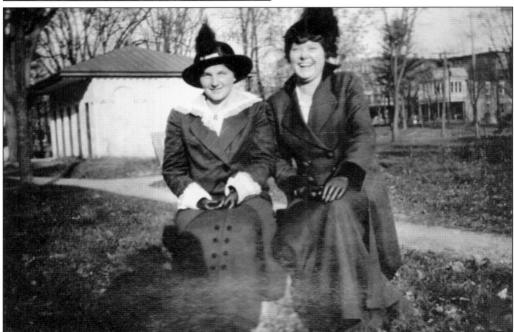

Posed on the south edge of park grounds in front of the shower building are Anna Lawyer (of the local jewelry family) and Zella Allen. Anna married Ed Carroll and was the mother of Margi Carroll McBee. Her grandchildren still live in the Berkeley Springs area. (Courtesy of McBee family.)

Even in winter, the park was an irresistible playground. The nine-bedroom Biddle summer cottage, named Ellen Gowan, adjoined park grounds. It was destroyed by arson in the early 1930s.

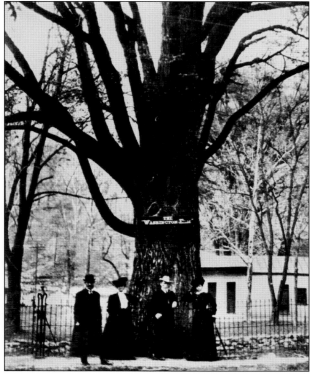

Legend had it that the giant elm at the southeast corner of the park grew from a switch stuck in the ground by George Washington. When it was removed because of decay in late August 1947, observation of the stump proved the tree much older. An iron fence around the Grove had been extended to include the elm in 1894.

Park employee Reid Johnson gazes at the Washington elm around the time of its removal. As early as 1909, local news reports mentioned the famous tree was showing signs of decay. A state tree expert came in 1924. It finally came down in 1947. Three gavels made from its wood were used in the 1952 Republican convention in Philadelphia.

Three

FAIRFAX STREET

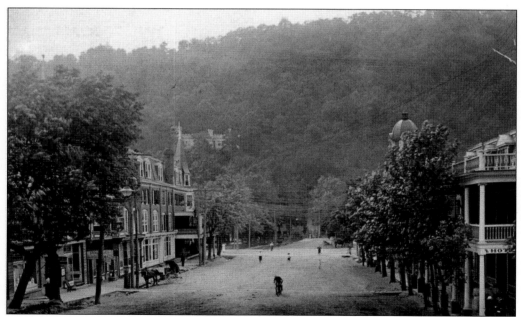

When members of the Washington family laid out the newly formed town of Bath around the warm springs in 1777, they planned the east-west path across the narrow valley as the main thoroughfare. It was named Fairfax Street after Thomas Lord Fairfax, who owned the land. It has remained the key location for business and government ever since.

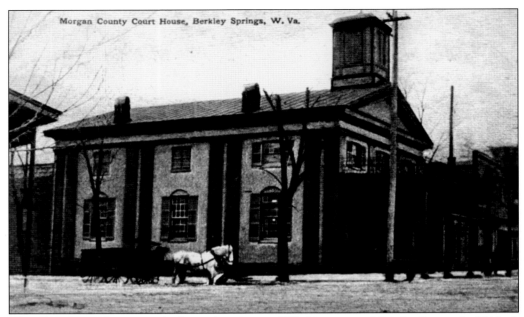

The second courthouse was built on the corner of Washington and Fairfax Streets in 1846. A portico was added later. The fountain at the building corner was placed by the Village Improvement Association in 1894 and moved to the park in 1908, where it remains today. The courthouse was razed in 1907. (Courtesy of Beth Peters Curtin.)

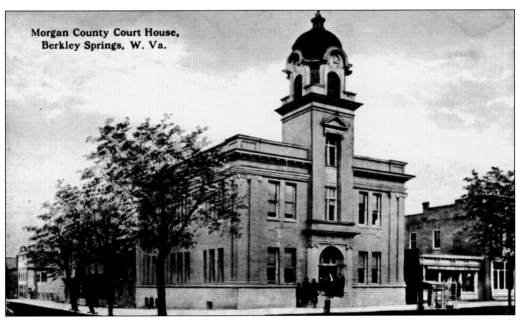

The third courthouse replaced its predecessor on the same corner in 1908. The town clock, with workings by P.R. Lawyer, was a signature item. An early morning fire on August 8, 2006, turned it to ruins without any loss of life. At the time of this postcard, adjacent buildings remained.

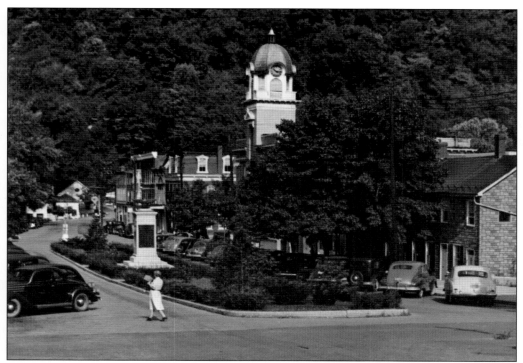

The 1948 postcard of Fairfax Street looking west is most notable for the diagonal parking. Also notable is the original façade on the corner building, just beyond the courthouse tower.

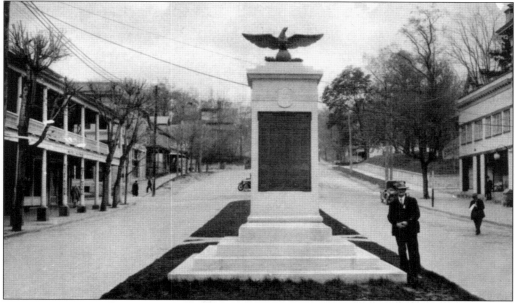

In 1916, a median boulevard was installed on the east side of Fairfax Street. The 15-foot Soldiers Memorial was unveiled on Armistice Day, November 11, 1925. Bronze tablets list names of men who served in these four wars: Mexican, Civil, Spanish-American, and World War 1. The memorial was made by J.F. Manning Company of Washington, DC.

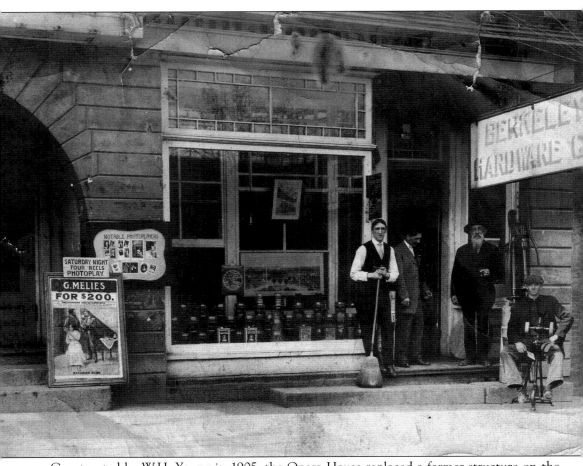

Constructed by W.H. Young in 1905, the Opera House replaced a former structure on the commercial block of eastern Fairfax Street. The first movies in town were shown there in 1909. It could seat 450 people. Berkeley Hardware occupied the western storefront in this c. 1910 postcard. Henry Harrison Hunter stands next to the knife sharpener; his son Latrobe, holding the broom, clerked at the store.

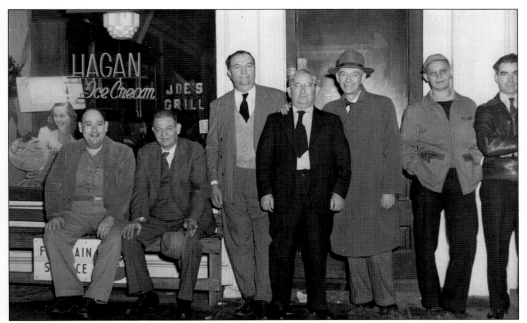

Joe's Grill served hamburgers and vegetable soup in the Hawvermale Building on the western side of the Opera House. Pictured here in the 1950s are, from left to right, Isodore Miller, Walter Harmison, Joe Hawvermale, Jake ?, Doc Stine, Tink Yost, and Vernon Weber. Joe Hawvermale owned and operated the grill for 43 years.

Businessmen like Walter "Toad" Harmison were the town's backbone. In 1921, Harmison was at the beginning of his varied career, with his billiards hall in a corner room of Harmison House next to the Dunn Hotel building on Fairfax Street.

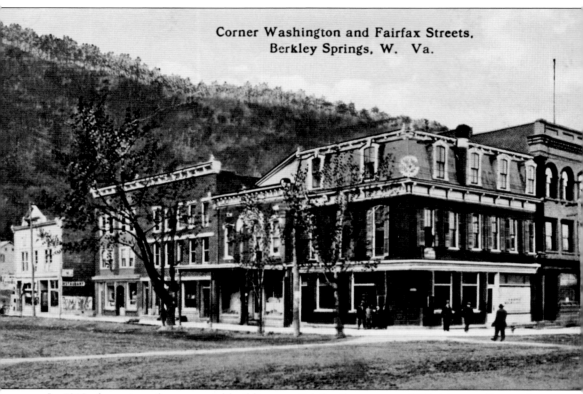

Corner Washington and Fairfax Streets,
Berkley Springs, W. Va.

In 1913, the string of commercial buildings on Fairfax Street west of Washington Street almost completely filled in the block after two destructive hotel fires. All but the farthest Bridge Café building remain in place today, although the detailed façade of the corner structure has been faced in yellow brick. (Courtesy of Beth Peters Curtin.)

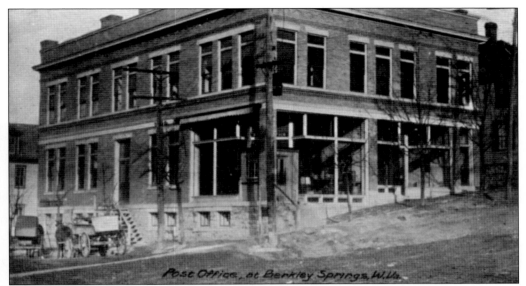

Post Office, at Berkley Springs, W.Va.

J.H. Hunter and Sons built an office building for Judge Kennedy of Pittsburgh on Mercer and Fairfax Streets. It housed the post office until 1961. The *Morgan Messenger* occupied the basement area in 1909 and remains there today. From 1914 to the mid-1920s, the easternmost room was used by the Women's Civic League as a rest room where country women could await their husbands doing business in town.

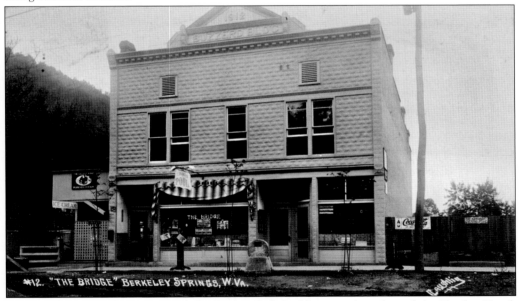

#12. "THE BRIDGE" BERKELEY SPRINGS, W.VA.

In 1911, the Buzzerds constructed the Bridge Café building on the ashes of the Fairfax Hotel. It burned the following year and was rebuilt the next. The Bridge Café advertised itself in 1918 as "the Delmonico's of Berkeley Springs." Teens in the 1930s met there after school. The brick structure was destroyed by fire again in 1981. The Sherrard buhrstone monument along the curb now sits in Berkeley Springs State Park. The Sherrards were instrumental in the formation of Morgan County in 1820. They owned most of this Fairfax Street corner. Their stone house was used as the first courthouse. (Courtesy of Beth Peters Curtin.)

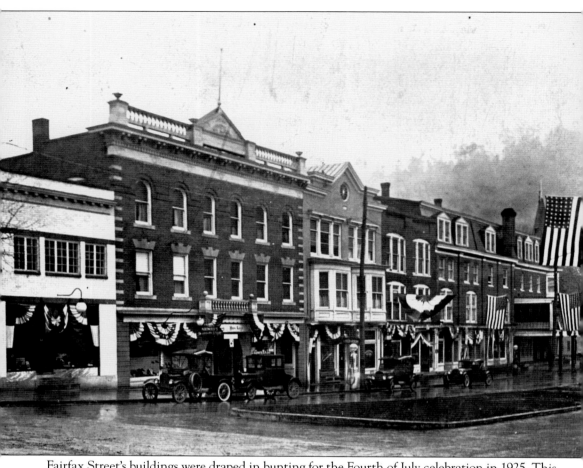

Fairfax Street's buildings were draped in bunting for the Fourth of July celebration in 1925. This area remained the commercial center for the next half century until a massive fire destroyed the entire block in 1974. Only the southwest corner of Fairfax Street is currently occupied. Over the years, trees, monuments, and historical signs have sprouted up in the median strip. Since 1976, the Foxglove Garden has planted and maintained it.

Four

INDUSTRY AND FARMS

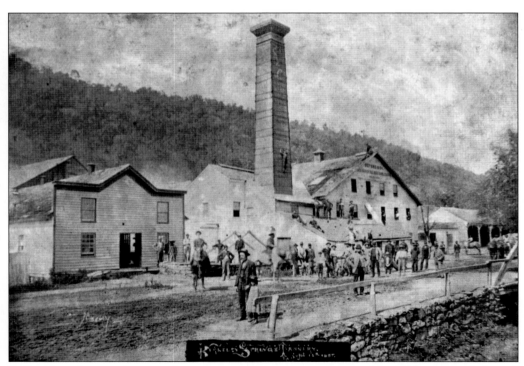

Railroads and tanneries were the primary 19th-century industries. The 20th century belonged to sand mining. Except for tomato growing and canning and some apple orchards, farming was always a subsistence activity. DeFord Tannery, less than a block from the springs, dominated downtown from the Civil War until the end of the century.

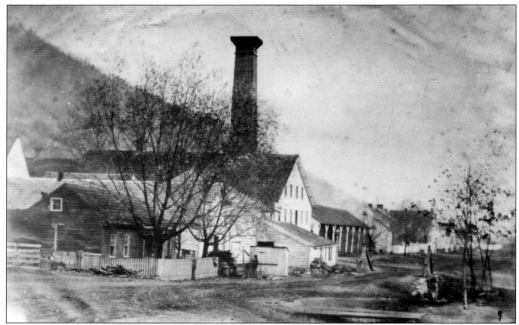

In spite of providing year-round employment and heavy investment in the town, Benjamin DeFord's large tannery was often under assault, especially by hotel owners and guests. Locals supported the tannery. Various huge tannery buildings stretched north along Washington Street.

The tannery purchased thousands of cords of rock oak bark harvested by local woodsmen and hauled to town on homemade wagons. It was an important cash crop. This shed on Washington and Congress Streets was one of several in which the bark was stored.

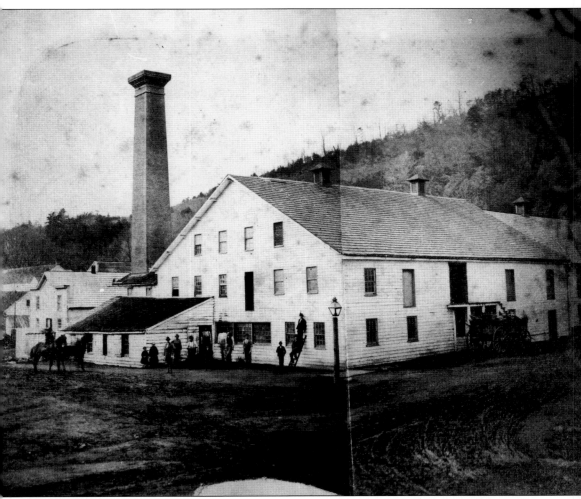

The main building of the tannery was on the southwest corner of Congress and Washington Streets. The large chimney was built in 1888 as part of a major expansion. By 1891, legal rulings and years of citizen pressure against the tannery for polluting Warm Springs Run caused it to close, although operations continued for several years. DeFord claimed the spring water made the leather harder. Before the turn of the 20th century, this structure was gone.

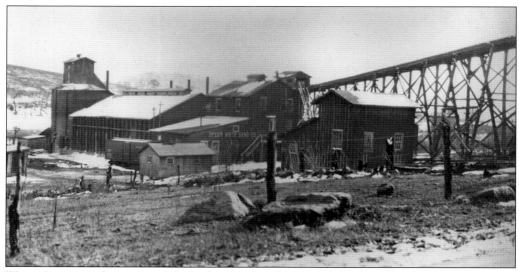

Warm Springs Ridge is one of the highest quality deposits of silica sand in the country. During the early 20th century, nearly a dozen mom-and-pop operations mined sand north of town. Speer White Sand Company built the first plant in 1879. All were absorbed by Pennsylvania Glass Sand in 1927.

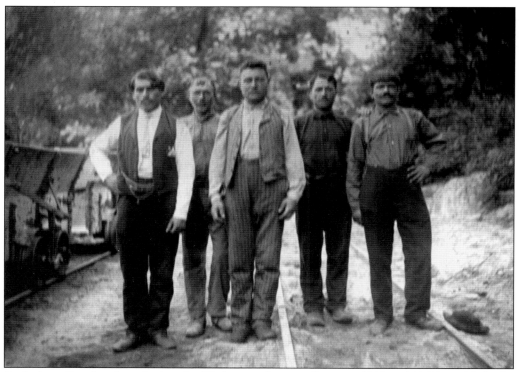

Both the railroad and sand mines had Italian work crews. Between 1905 and 1907, trouble broke out between cheap foreign labor imported by sand companies and local workers. One of the foreign workers was killed in 1907, sparking a mine strike.

Sand mining replaced the tanneries as a major source of employment for local men. Miners used sledgehammers and wedges to break large rocks into smaller ones that were transported by mule-drawn carts to steam-powered crushers and mills. In 1893, the sand mined here by Henry Harrison Hunter won a blue ribbon for quality at the World's Columbian Exposition in Chicago. (Above, courtesy of Becky Kuykendall and US Silica.)

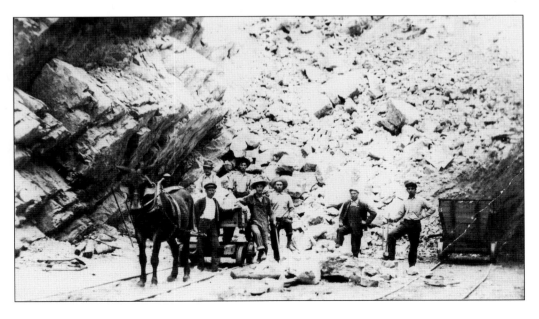

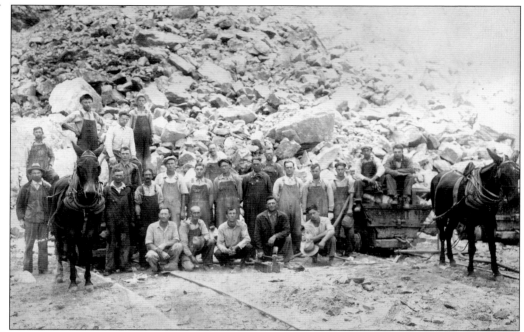

Workers at sand mine No. 6 are pictured in 1931, around the time mules were being phased out of the mines. By then, all the individual sand mines along the ridge were consolidated into Pennsylvania Glass Sand, and the work to turn that company into a world-class facility was beginning.

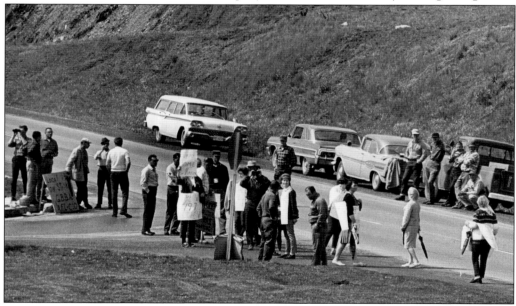

Although there were deadly explosions in the early years, it was not until 1967 that Pennsylvania Glass Sand was organized by the Teamsters Union. A three-year lockout of 38 men ensued, and there was ongoing picketing in the early weeks. A federal court trial in Berkeley Springs eventually settled the strike, and the company was ordered to reinstate the men. Soon after, the locally owned company was sold to International Telegraph and Telephone (ITT).

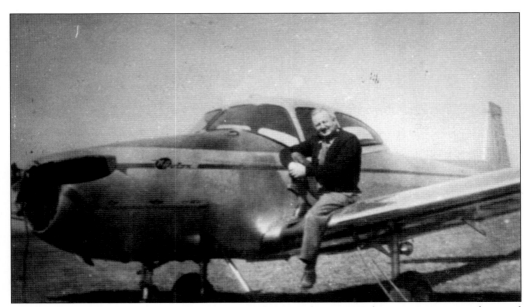

Earle T. Andrews was hired by Pennsylvania Glass Sand in 1929. The young engineer designed and built a new Berkeley plant, the largest and most technologically advanced silica facility of its time. He became general manager in 1941. When he took over as president in 1963, the company was still the largest plant of its kind in the world. He was an enthusiastic pilot. (Courtesy of Luella Andrews.)

For nearly 20 years, Tom Shufflebarger was head geologist for Pennsylvania Glass Sand. Also serving for more than a decade as county commissioner, he was devoted to protecting the source of the famed warm springs. (Courtesy of Becky Kuykendall and US Silica.)

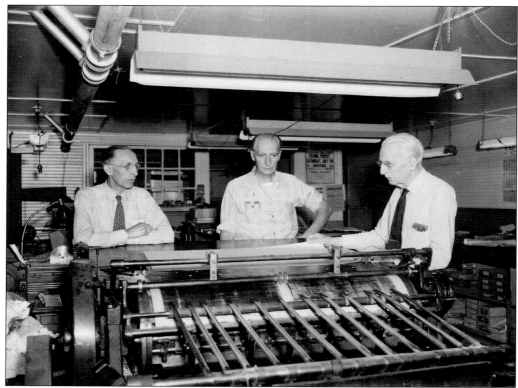

Simeon Strother "S.S." Buzzerd founded the weekly *Morgan Messenger* in 1893. It remains in operation as the county's only newspaper and job printer. In this 1949 photograph of S.S. and his sons, Lewis, who began working at the paper in 1933, is on the left. Jim, center, began in 1927. (Courtesy of the Buzzerd collection.)

Interwoven Stocking Company in Berkeley Springs was a branch of the main plant in Martinsburg. It was built at the north edge of town in 1921 and filled with rows and rows of knitting machines. Operating until 1954, it primarily made men's white socks. (Courtesy of Bob Ayers.)

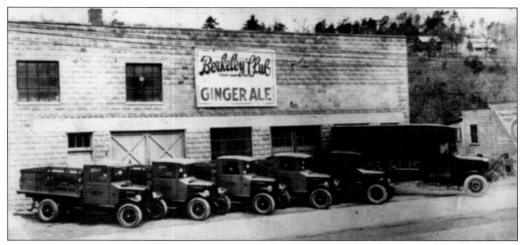

Berkeley Springs Bottling Works opened in 1924 and soon moved to its current location next door. An addition and new equipment followed. In 1929, ten new trucks were added.

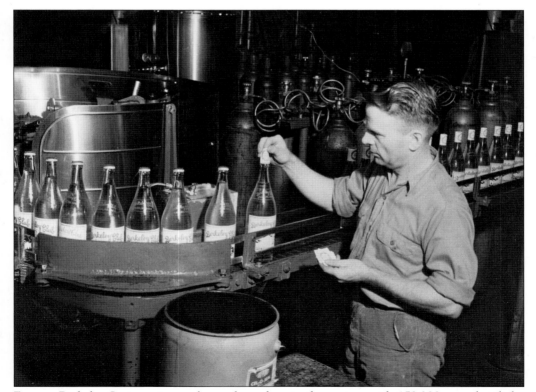

Famous Berkeley Springs ginger ale was legendary in the region, with 150,000 cases bottled a year. Nearly a dozen other flavors included lime, grape, sarsaparilla, and cream. Dupont used Berkeley Club to experiment with a new seal for bottles. Pictured is Ray Fearnow putting on a Christmas seal in 1956.

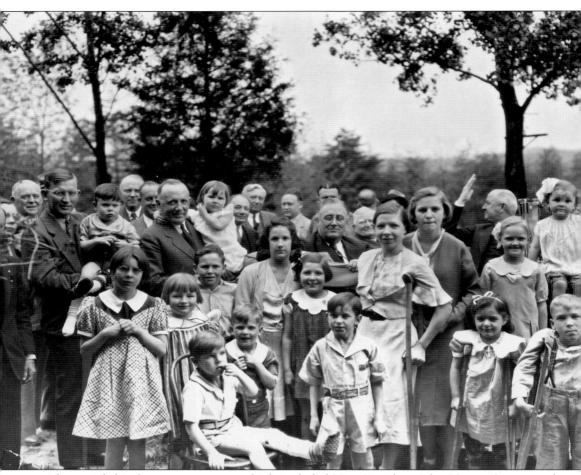

Along with his famous entourage, which included Vice President John Nance Garner and Postmaster General James Farley, US President Franklin Delano Roosevelt was joined by local men of distinction on May 12, 1935. The children were residents of the polio clinic at the Pines in Berkeley Springs, which FDR visited. He also toured Berkeley Springs State Park. President Roosevelt was on his way to nearby Woodmont for a trout fishing getaway.

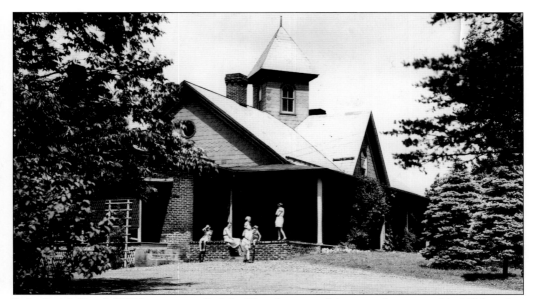

Judge Josiah Dent's 1893 home was called the Pines because of the trees that covered its hill location east of town. In 1934, a joint project of the West Virginia Foundation for Crippled Children and the state's Relief Administration opened a paralysis clinic "using the medicinal waters of Bath as center of the clinic," according to an official pamphlet on the project.

In 1938, an addition was made to the original building at the Pines. It included the therapeutic pool filled with the local mineral waters, marking the first time water was used to treat the disease in West Virginia. The photograph was part of a 1939 article in *Kiwanis Magazine*. The local club raised funds for the expansion. (Courtesy of War Memorial Hospital.)

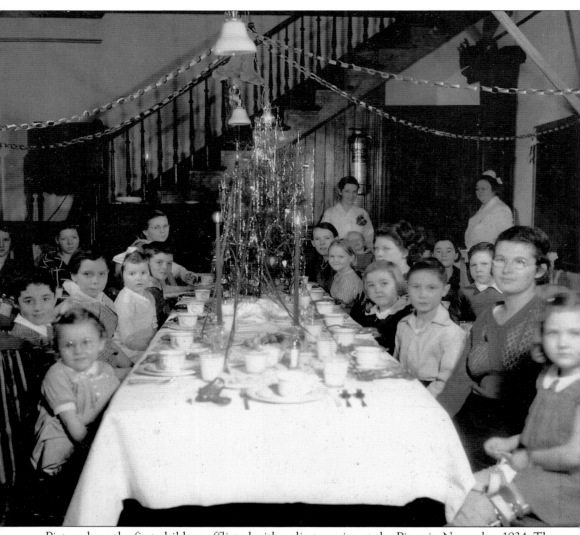

Pictured are the first children afflicted with polio to arrive at the Pines in November 1934. The hospital staff treated its patients like family, as demonstrated by the Christmas dinner. Children stayed in wards, and school came to them if they were unable to leave their beds. (Courtesy of War Memorial Hospital.)

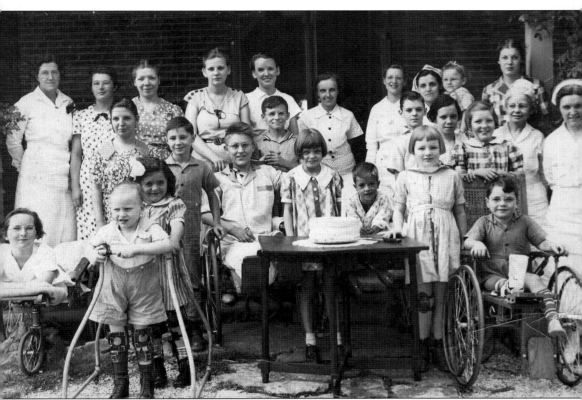

Birthdays were a cause for celebration among the children and staff of the Pines, as shown by this photograph taken June 10, 1936. The idea for the paralysis clinic as a way to revitalize Berkeley Springs grew out of the 1932 George Washington bicentennial celebration. The Pines continued in operation until 1947, when it began its transformation into a local, general-use hospital. (Courtesy of War Memorial Hospital.)

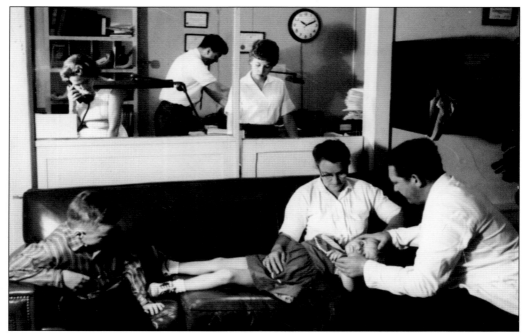

For three years, Berkeley Springs community leaders worked diligently to raise the funds to turn the Pines into a local care hospital. In 1950, War Memorial Hospital was dedicated. More fundraising took place, and in 1960, the public was introduced to an expansion that included an emergency room, a new operating room, and an x-ray machine. A new wing opened in 1963. The hospital served the community in the same location until 2012. (Both courtesy of War Memorial Hospital.)

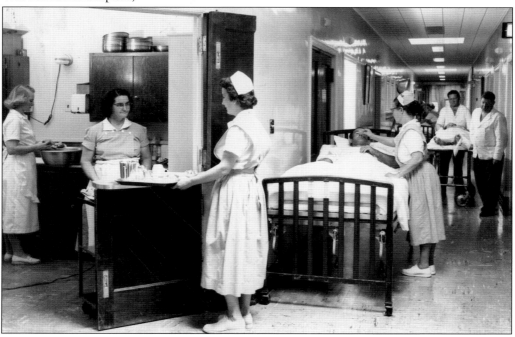

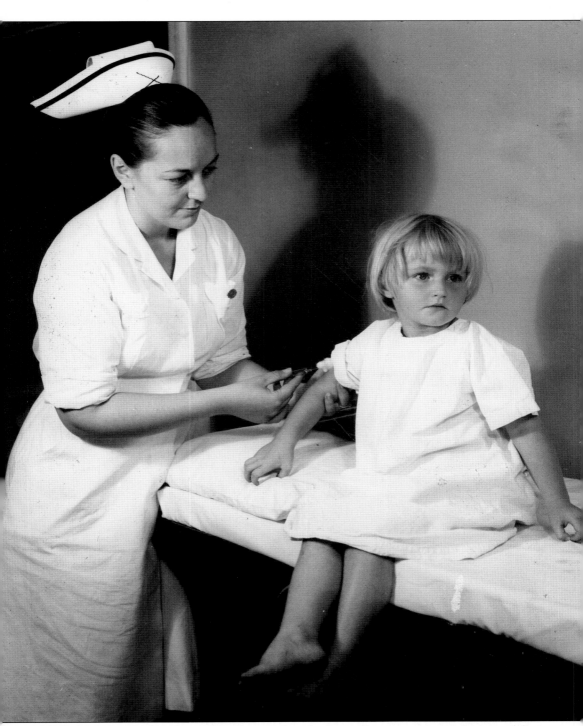

In 1959, Mary Lou Loftus (later Trump) arrived at the hospital to serve as anesthetist and first director of nurses. The child in the photograph is Diane Hiles; her older brother was one of Trump's first patients. (Courtesy of War Memorial Hospital.)

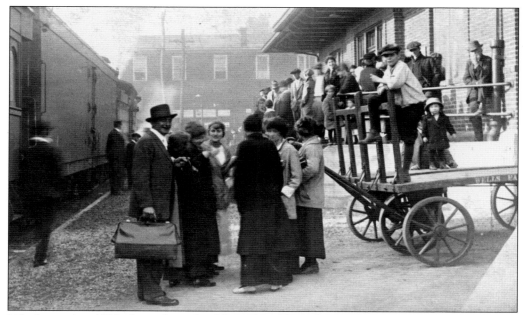

Life changed in 1888 when a branch of the railroad brought train passengers directly into town, ending the challenging stagecoach ride over several miles of rough roads from stops along the river. But one day, someone greased the wheels and the track. The train went sailing beyond the station into the building just to the south. (Courtesy of John Douglas.)

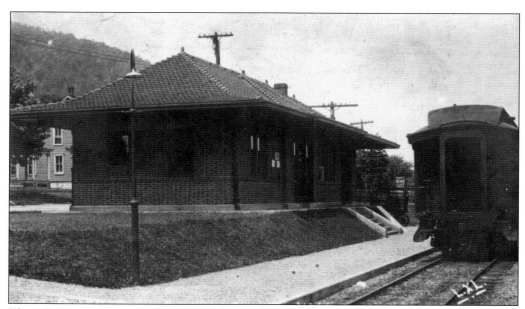

The Mission-style train station replaced an earlier structure in 1915. It was used for passengers until 1935, when service ended. Once the expanding sand industry made it profitable, the B&O Railroad bought the locally developed short-line railroad at a tax sale on the courthouse steps in 1910 and built the station. (Courtesy of McBee family.)

Many men throughout Morgan County found good jobs working on the B&O Railroad. This trio includes, from left to right, Rumor Spring, "Sticky" Kline, and Russell Rankin. (Courtesy of John Rankin.)

The northern end of Warm Springs Ridge abuts the extensive B&O Railroad tracks along the Potomac River. Mining operations in the area occasionally shook sandstone boulders loose. This scene is upriver from the Hancock Bridge. (Courtesy of Becky Kuykendall and US Silica.)

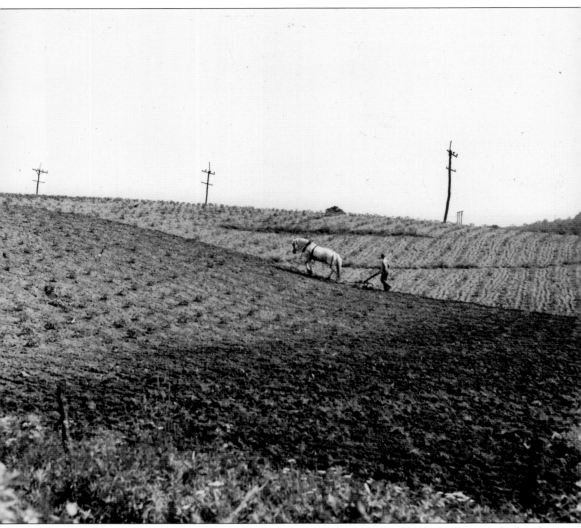

Tomatoes were the major commercial crop from 1890 through World War II. During the heyday, more than 2.5 million quarts of tomatoes were packed by local canneries in nearly 30 locations. The canneries employed 2,000 to 3,000 people each two-month season. By 1934, half the tomatoes grown in West Virginia came from Morgan County. This 1949 United States Department of Agriculture photograph of Loyal Goller practicing new plowing techniques on the AG Goller farm was taken during the end years of the industry, after blight and war took their toll. (Courtesy of the United States Department of Agriculture.)

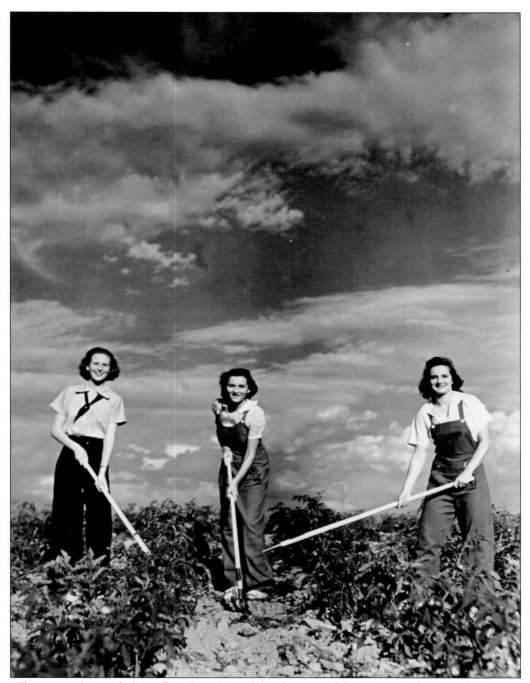

"These very pleasant ladies reflect the spirit and the character of that increasingly important tomato county," wrote one newspaper. This Henry Ruppenthal promotional photograph for the 1938 Tomato Festival was the front cover of the 1939 Stokes Seed catalog, which was seen by millions.

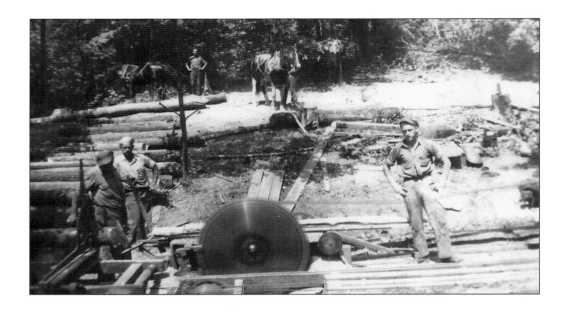

Forested ridges and hills supported industries from small-scale timbering to bark harvesting for the tannery. Every small settlement had a family-owned and operated sawmill. Above is the Risinger sawmill, which operated in the Cherry Run area in the 1940s. Below is a steam-driven sawmill on the site of today's Berkeley Springs High School ball field. The same area was the site of late-19th-century tournaments featuring knights on horseback. (Above, courtesy of Morgan Messenger.)

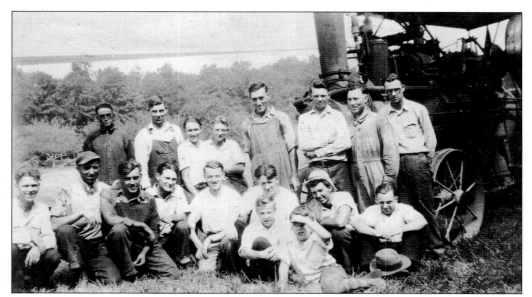

Harvest time meant neighbors sharing men and machinery. Bub Spriggs brought his threshing machine to the Swaim farm in the 1930s. Even visiting preachers pitched in to help. (Courtesy of Tommy Swaim.)

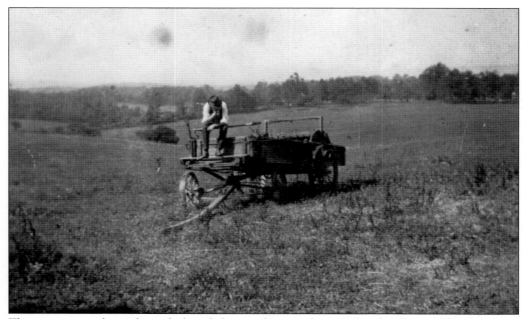

The manure spreader made an ideal perch for a quick nap in the sun. Theodore Eversol ("Uncle T") was working the Hovermale farm along WV9 east in the 1920s. (Courtesy of Julian Hovermale.)

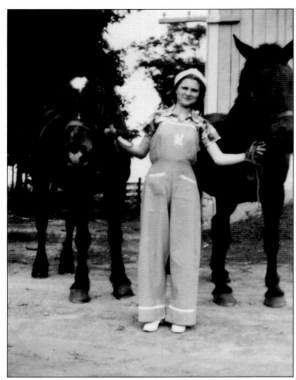

Seen here just before World War II are Cousins Marguerite (left) and Gladys Kesecker (below). They were shining examples of young farm girls who married local farm boys around this time and spent their lives working the land, raising families, and contributing to their communities. Both lived on farms in the eastern sector of the county. (Left, courtesy of Julian Hovermale; below, courtesy of Gladys Butts family.)

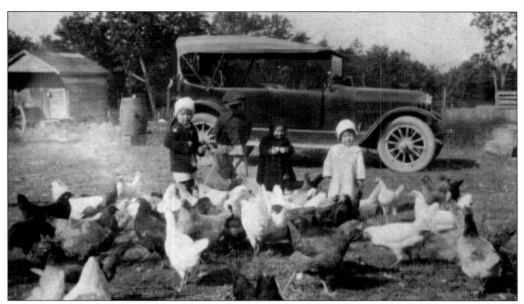

Farming was a family affair through all Morgan County history. In 1921, the Hovermale children—(from left to right) Stuart, Edward, Rider, and Julian—were surrounded by chickens, with the farm smokehouse in the background. (Courtesy of Julian Hovermale.)

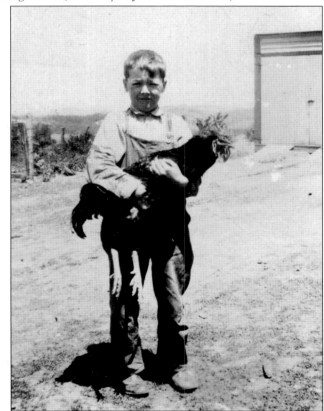

Julian Hovermale holds a giant rooster. Julian went to work at Interwoven Stocking Company but left in 1942 because his father needed him on the farm. He married Marguerite Kesecker, whom he met at Interwoven. He has been farming ever since. He is the third generation of Hovermales to farm the land. (Courtesy of Julian Hovermale.)

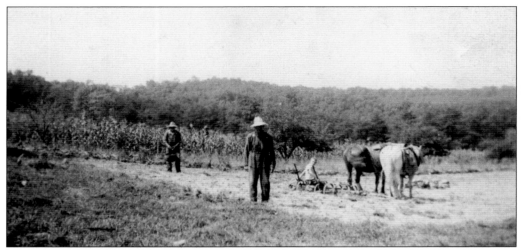

This photograph was taken in August 1946 on the Michael farm in the Highlands section. Pictured are Fairbee Michael (left), his brother Romanus, and cousin Bobby Lee sitting on the harrow. (Courtesy of Mary Michael Mellott.)

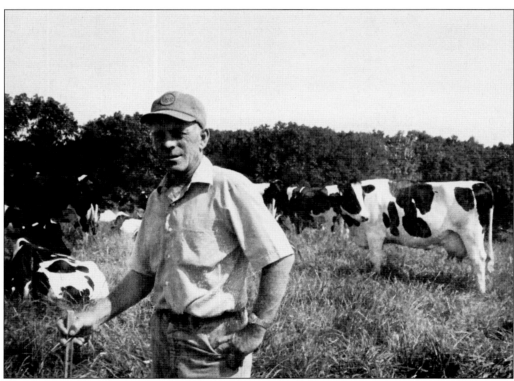

The Michael dairy farm was one of several in the county. When Kenny Michael's father died suddenly, young Kenny took over and ran the farm for the next 60-plus years. (Courtesy of Kenny Michael family.)

Chickens were a staple on Morgan County family farms. Fairbee Michael is pictured on his Highland-section farm; scenes such as this happened daily all over the countryside for more than 200 years. (Courtesy of Mary Michael Mellott.)

Nelson Kesecker's cattle farm on Highland Ridge, pictured in 1941, was typical of the pastoral scene through most of the county. In later years, Kesecker served several terms as a Morgan County Commissioner. (Courtesy of Gladys Butts family.)

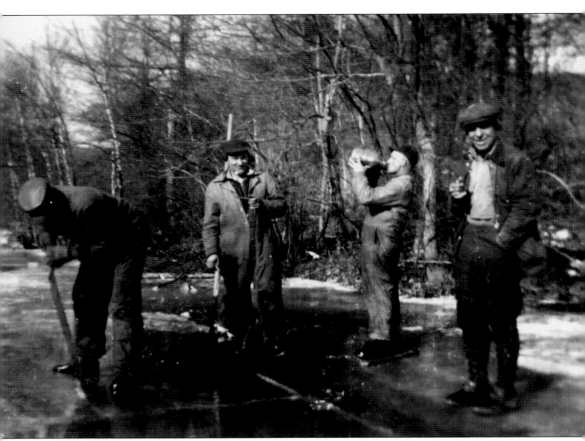

Cutting ice to sell and use on the home farm to preserve food was cold work and needed a warming boost from a homemade beverage. From left to right, the faces visible are of Roscoe Swaim, George Lutman, and Tracy Lintz as they cut ice on Mountain Run in the 1930s (the man on the left is unidentified). A constant task for local families, it earned mention in the local newspaper as early as 1886. (Courtesy of Linda Swaim Buzzerd.)

Five

FESTIVALS AND PARADES

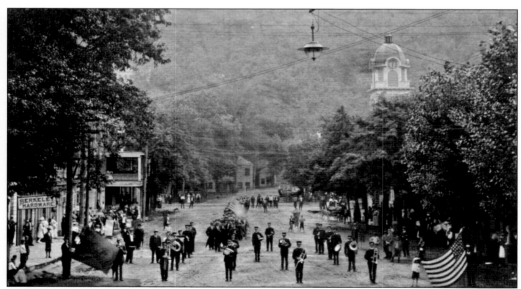

Parades and festivals were a regular feature of local life. During the Victorian era, festivals centered on summer people and the big hotels. There were tournaments with knights and horses, band dances, and elaborate Fourth of July celebrations. As life became more locally centered in the 20th century, community bands marched, and the themes were both patriotic and agricultural. The Berkeley Springs Band played on Fairfax Street around 1915. (Courtesy of McBee family.)

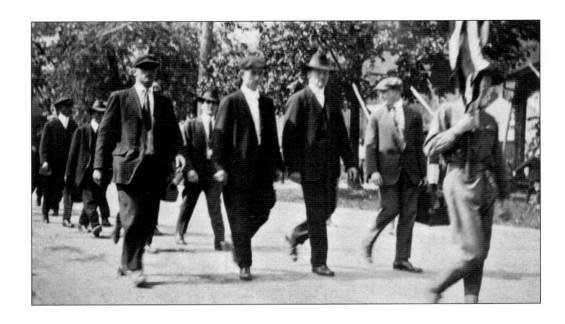

World War I inspired a patriotic fervor with festival-like war bond drives and honor escorts of town citizens when local men left for the war. Everyone marched along with this group setting off to Camp Lee in Virginia in 1917. The destination of the parade was the train station north of town. (Both courtesy of the Buzzerd collection.)

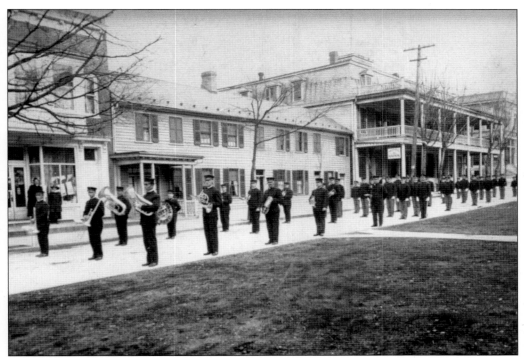

The Berkeley Springs Band once again marches on Fairfax Street, this time in 1917. The Dunn Hotel is prominent in the background, along with the Harmison/Heare house.

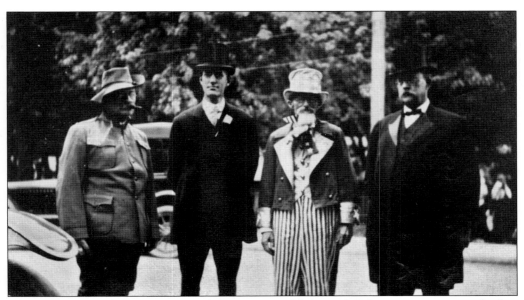

Identified as part of a homecoming celebration, most likely in 1917, four prominent town leaders dress up as patriotic figures. From left to right, Will Disher is Teddy Roosevelt, Jim Dunn is Woodrow Wilson, Abner Morgret is Uncle Sam, and banker Allen Mendenhall makes an ideal William Howard Taft.

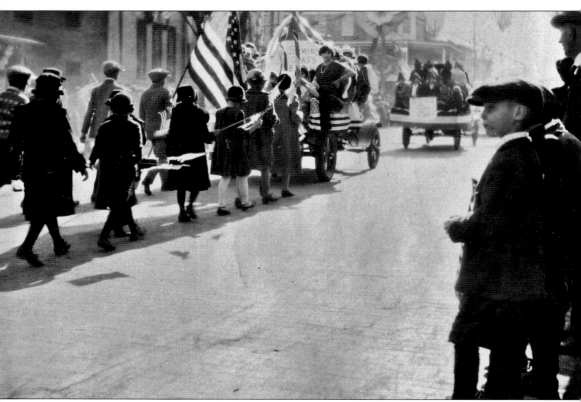

Armistice Day of 1925 was a major celebration. It was marked by the unveiling of the Veterans Memorial that still stands on the landscaped center strip of Fairfax Street. The event included band concerts, parades, and speeches.

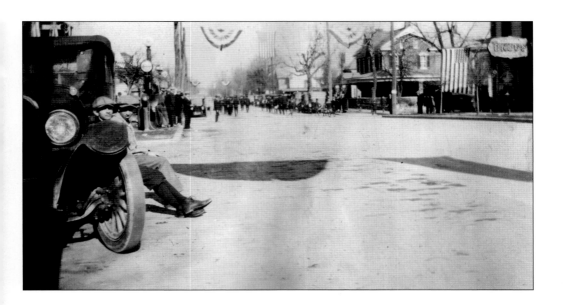

Here are additional artful views of Armistice Day in 1925. Above is the corner of Congress and Washington Streets, looking north. Below is a bunting-strewn Fairfax Street, looking east toward the newly erected Veterans Memorial in front of the courthouse.

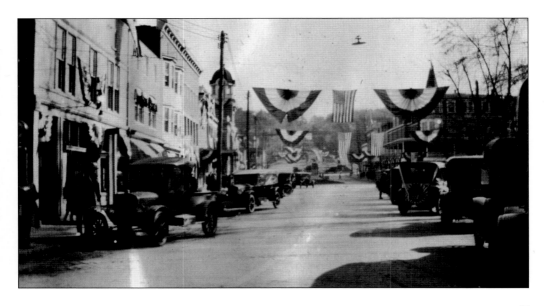

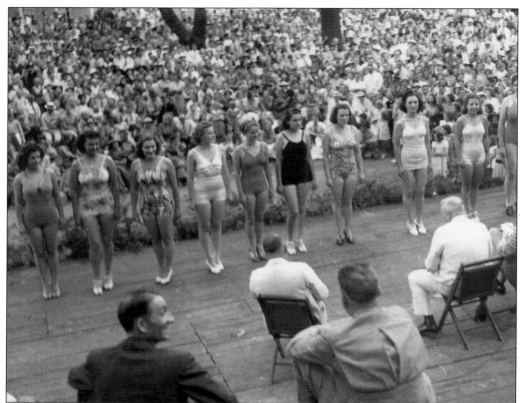

Held annually over Labor Day weekend from 1937 to 1941, the Tomato Festival drew tens of thousands of visitors to Berkeley Springs and garnered enormous publicity in newspapers throughout the region. The Young Men's Business Club produced the festival. The bathing beauty contest (above) was a favorite event. It was held in the park on Labor Day Monday, the last of the four-day celebration. Newly elected governor Homer Holt was among the judges at the first festival.

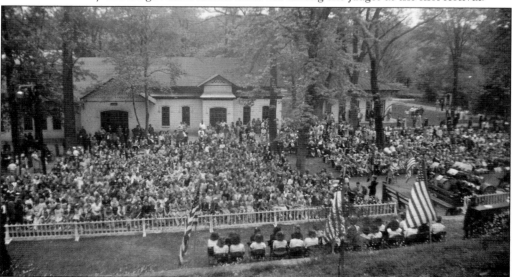

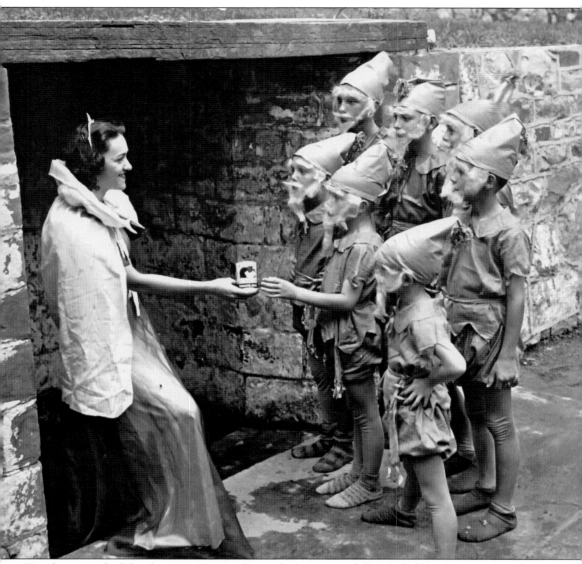

Weather was ideal for the 1938 Tomato Festival pageant. A full 120 children were cast in the pageant, including Anna Mae Weber, who played Snow White. Standing in the Ladies Spring, she gives the seven dwarves a delicious drink of tomato juice. The festival and subsequent publicity substantially bolstered the prominent tomato industry and helped get that same local tomato juice served at the 1939 New York World's Fair.

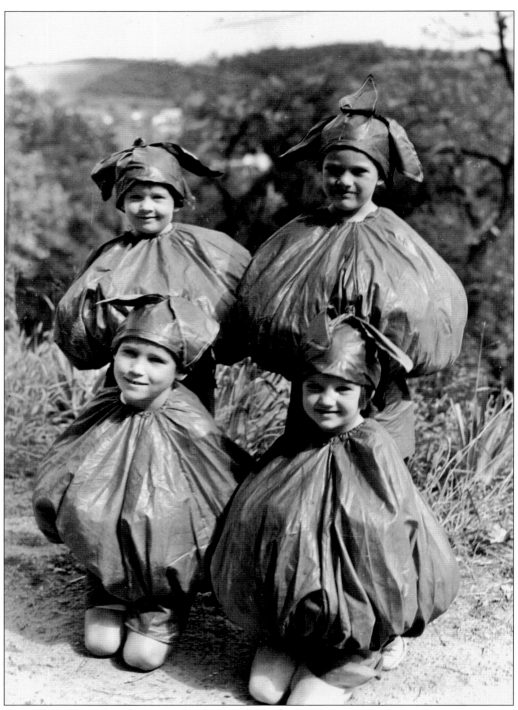

Some 17 children played green and red tomatoes in the 1938 pageant, including future newspaper publisher Warren Buzzerd and future prosecuting attorney Sammy Trump. Dozens more portrayed everything from raindrops to blossoms.

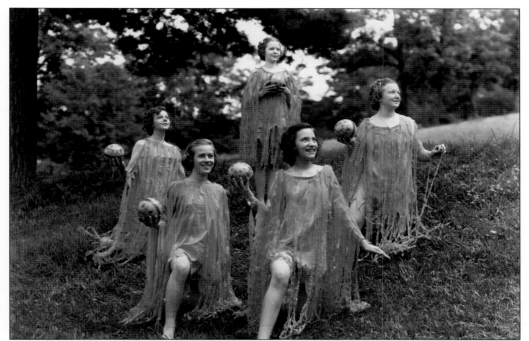

Local volunteers wrote, directed, and created all the costumes for the Tomato Festival pageant each year. It was staged twice during the festival: on Saturday and Labor Day Monday afternoon. Local young women yearned to perform in the pageant.

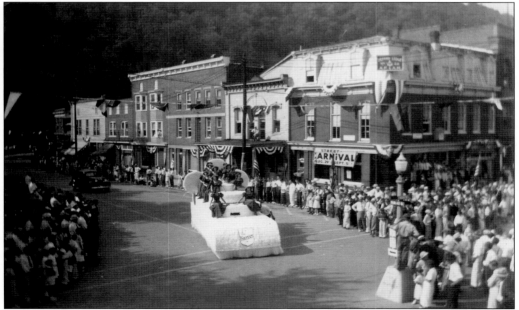

The Grand Parade dominated events on Labor Day Monday of the Tomato Festival. The parade route moved north along Green Street, traveled down Fairfax Street and past the courthouse, wound onto Wilkes Street, and concluded by heading around the park, first on Fairfax Street and then south on Washington Street.

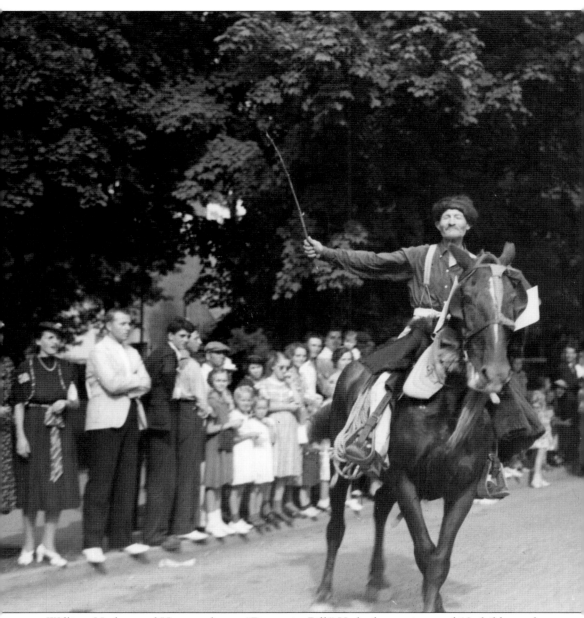

William Underwood Hovermale was "Dynamite Bill." He had two wives and 13 children, plus a horse named Mag that he trained to be in parades. Bill's farm in Cold Run Valley is now known as the Benedict farm. He died in 1952 at age 76. Local legend claims his nickname came from how he motivated his mules.

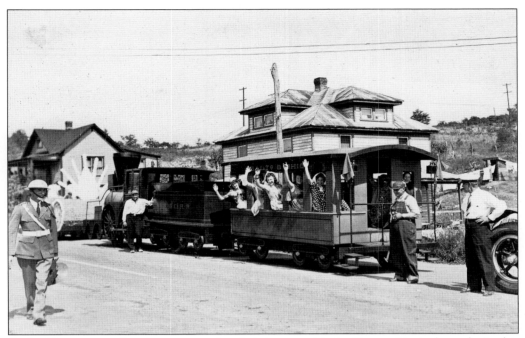

Sticky Kline was a railroad man even when helping out with the Tomato Festival parade. In this photograph from the 1940 event, the popular caboose float is lining up south of town. It stood out from the long stream of flower-draped floats.

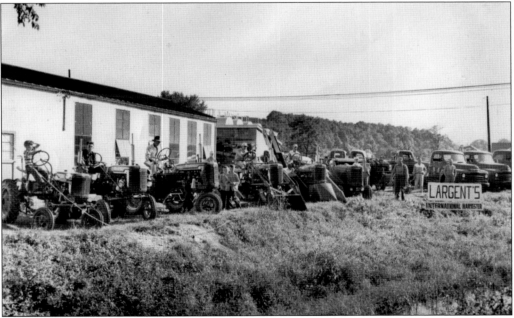

Largents Truck and Implement Center was a popular exhibitor at the annual Morgan County Fair held on the grounds of Berkeley Springs High School in 1949. This was the second incarnation of the county fair. The first, produced by the Village Improvement Association, originated in 1893 and was staged on the plaza of the Berkeley Springs Hotel. (Courtesy of Nancy Largent.)

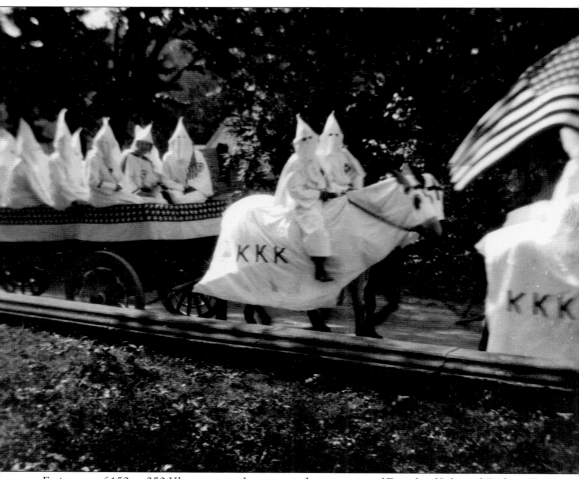

Estimates of 150 to 250 Klansmen and women rode in a series of Fourth of July and Defense Day parades in 1924, 1925, and 1926. Some rode in masks, and others were unmasked. Many locals, including band members, refused to participate in the parade if the Klan was masked. In Berkeley Springs, the Klan was primarily antiforeigner. (Courtesy of McBee family.)

Six

FIRES AND FLOODS

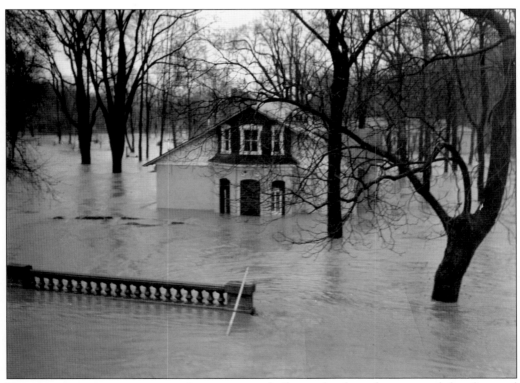

Two rivers, numerous streams, and a resort town built mostly of wood guaranteed that fires and floods often worked as unwelcome catalysts for redevelopment. Time after time, the town always recovered. In the epic 1936 flood, which began with heavy rains on March 16, Warm Springs Run turned Berkeley Springs State Park into a lake and filled the Victorian-era covered indoor pool with mud.

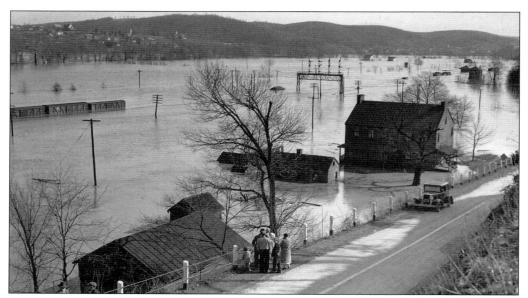

The 1936 Saint Patrick's Day flood was the worst in Morgan County history. The Potomac River was pushed over its banks, and the middle span of the Hancock Bridge washed away. Houses and shops near the river were gone, and 1,100 people were inoculated against typhoid. The trains did not run until early April, while it took nearly two months before the bridge reopened. Within a year, a new bridge was planned. It was built and opened in 1939. (Above, courtesy of Jessie Hunter; below, courtesy of Bob Ayers.)

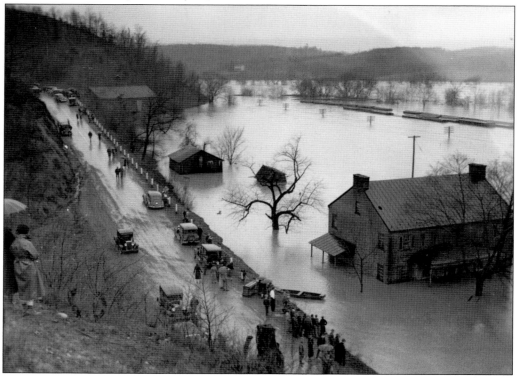

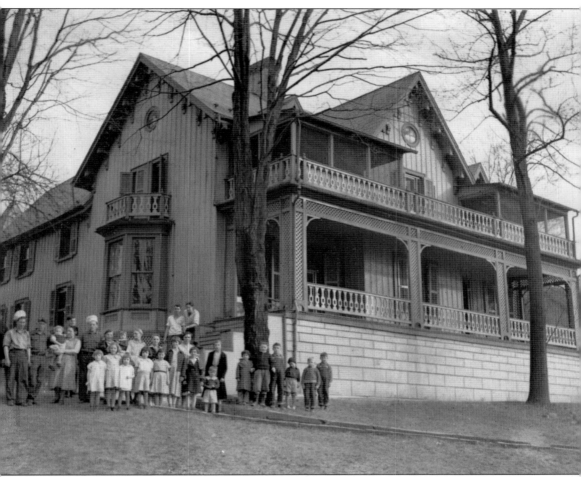

Two weeks before the 1936 flood, C.L. Hunter bought the historic De Freese house on Mercer Street as a new location for his funeral parlor. When the March 17th flood made 600 people homeless, Hunter stopped renovations and turned his building into a refuge center for 75 men, women, and children. The house was built in 1867 by John De Freese, Abraham Lincoln's government printer. It was originally called Woodbine. (Courtesy of Jessie Hunter.)

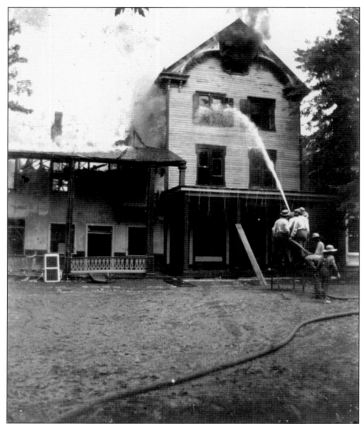

Built helter-skelter beginning in 1794, the sprawling Fairfax Inn, under a variety of names, dominated most of the Fairfax Street block facing the park. On July 17, 1901, the main section of the hotel on the east side of Warm Springs Run burned. The midday fire started in the kitchen/ironing room. Everything went wrong in fighting the fire, including a delay in calling for help, burst hoses, and low water levels. Within two hours, all was in ashes. None of the nearly 50 guests in the hotel were harmed. Three years earlier, the even larger Berkeley Springs Hotel burned, leaving the resort town without a major hotel as the 20th century dawned. (Both courtesy of McBee family.)

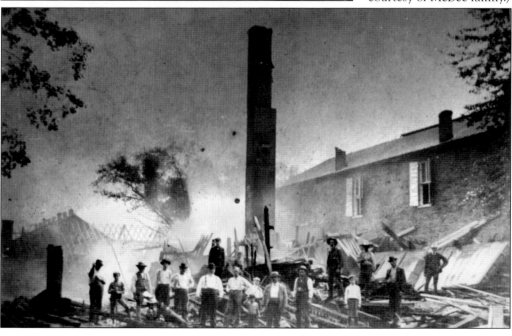

Twelve people died on August 25, 1974, when a smoldering basement fire in the Washington Hotel burst into flames at 3:00 a.m. and burned for five hours. Town policeman and volunteer firefighter Lee Fox discovered it. The hotel was destroyed, along with the adjacent Fairfax Street block of five, 19th-century commercial buildings. The fire wiped out nine businesses. Approximately 25 people were rescued, including 6 who were trapped on a ledge. One small structure was rebuilt almost immediately. Most of the block is still vacant. It remains the deadliest structure fire in West Virginia. (Both courtesy of McBee family.)

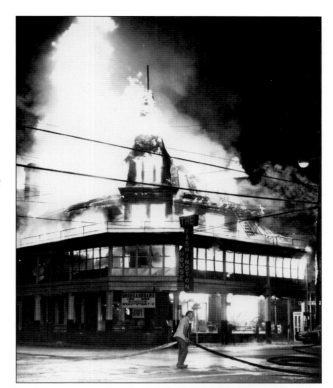

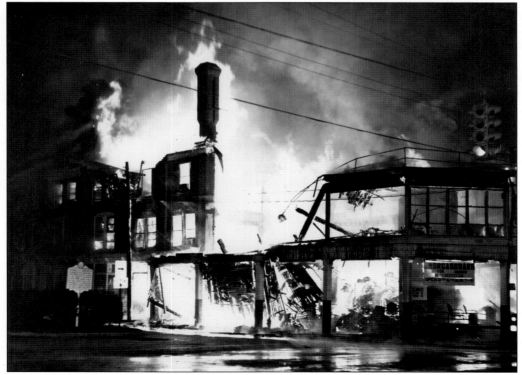

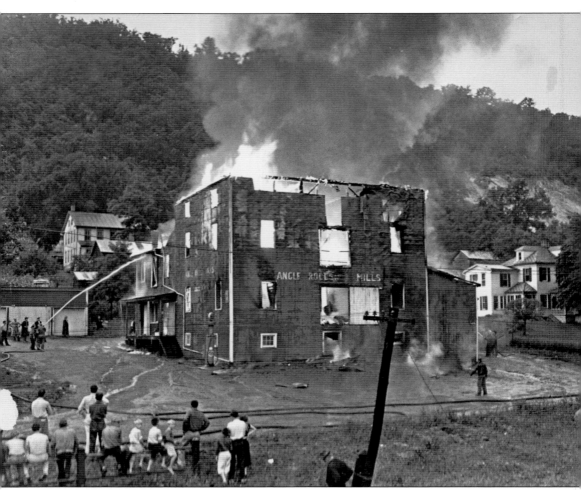

Two previous flour mills in the same location, at the north end of town, eventually became the Angle Roller Mill in 1934. Angle manufactured both flour and feed, using a power source that went from steam to gasoline and then to electric. The mill changed hands in 1950 but retained the Angle name. About 1957, it burned. The remaining structure was demolished, and Hovermale Produce was constructed on the site. That building still stands. The Crosfield House, visible on the right, was razed in 2001. (Courtesy of Lewis Braithwaite.)

Seven

HOTELS

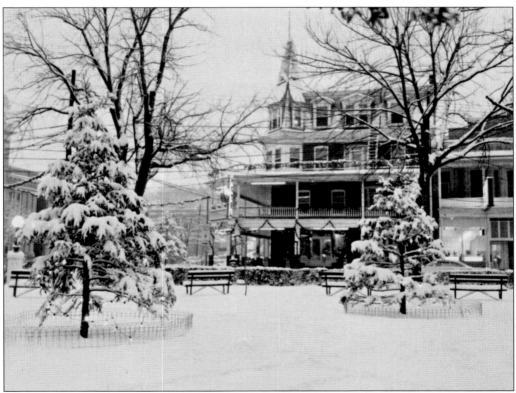

In 1776, a town was formed around the springs for the express purpose of encouraging lodging places to be built for those coming to take the waters. Ever since, hotels—large and small—have been the economic backbone of the town. Hundreds of hotel rooms and summer cottages during the golden age of the 1880s and 1890s made Berkeley Springs the chicest resort in the region. Snow decorates the Washington Hotel around 1960. (Courtesy of STAR Theatre.)

For more than a century, the lodging place on the north side of the park grew bit by bit under various owners and bore several names. The walkway and annex were built by a former Confederate, Dr. Charles Green, in 1872. By 1912, all of it had burned.

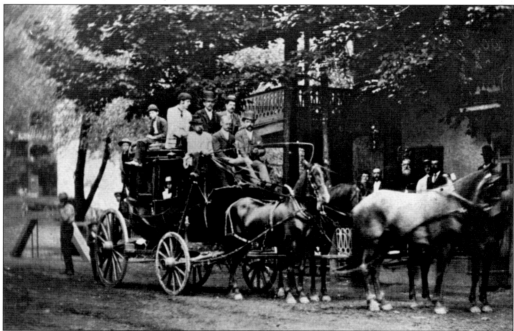

The La Pierre stage brought travelers, including US President James K. Polk, from the train station at Sir Johns Run over three miles of a twisting, rutted wagon trail to town. A bugle would blow as it came down the mountainside, and hotel guests would rush out to greet their arriving friends. Owner Charlie Jack sat behind the horses on the right. Soon after this photograph was taken in 1888, the train came to town, and the coach was retired.

Whether known as the Fairfax Inn, the St. Charles, or the Florence House, it was the only year-round 19th-century hotel. Its most famous owners were the pre–Civil War O'Ferralls, whose son Trip fought with Stonewall Jackson and went on to serve as governor of Virginia. By the close of the 19th century, it was famous for its saloon.

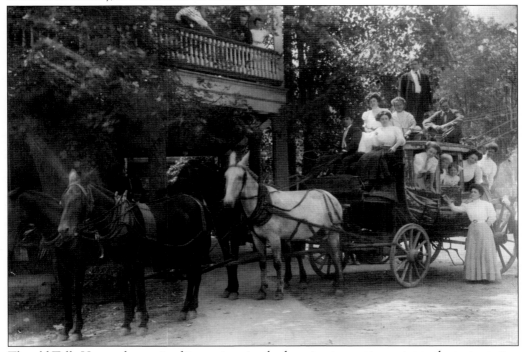

The old Tally Ho coach remained in service, simply changing its starting point to the train station in town. It was driven by mule instead of horse by the early 20th century. With the old hotels gone, guests were taken to the Washington Hotel.

Businessman George Biser stands on the porch of the former Gustin House with his daughter Claude and adopted son Lawrence. Biser turned the antebellum mansion and lodging place on the corner of Washington and Fairfax Streets into the Washington Hotel.

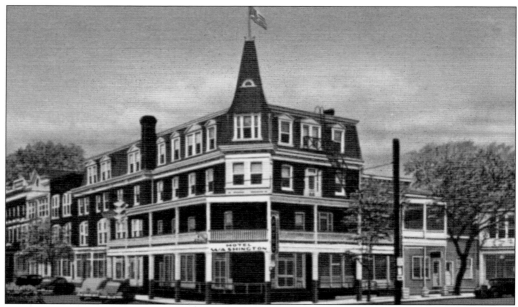

Biser built the Washington Hotel in 1905 to replace rooms lost in previous fires. Eventually, a fourth floor, a tower, and two wings were added to create 120 rooms. Until 1974, when it burned, the Washington Hotel was the anchor for the major commercial block on the eastern side of Fairfax Street.

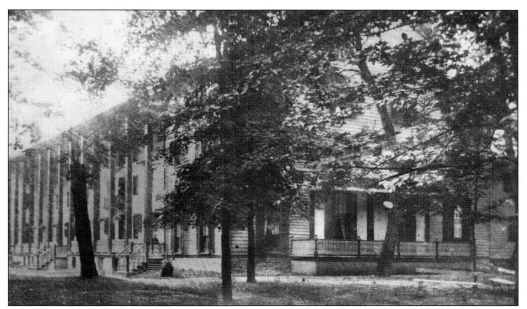

The Berkeley Springs Hotel, built by John Strother in 1848 on the south edge of the park, was the town's most famous. Presidents and other notables were among its hundreds of guests each season. Stonewall Jackson was an invader, not a guest, when he housed his men there in 1862 during skirmishes in the area. In Victorian times, it was noted for fancy balls and daily band concerts. It burned in 1898.

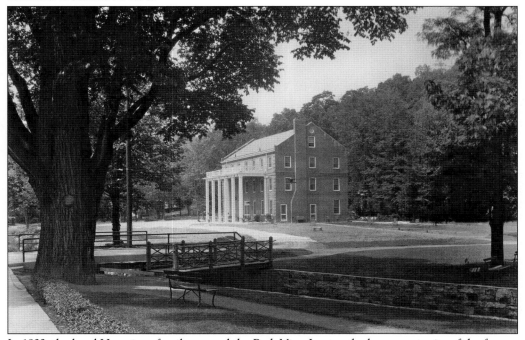

In 1933, the local Harmison family opened the Park View Inn on the long-empty site of the former Berkeley Springs Hotel. The year-round hotel was so popular that two wings were added in 1937. It has been the Country Inn since 1972. The Washington Elm stands in the foreground.

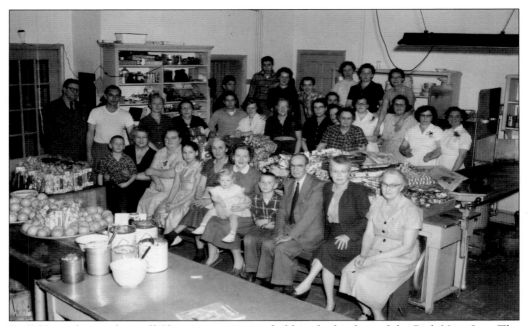

In 1954, as always, the staff Christmas party was held in the kitchen of the Park View Inn. The first woman seated to the left in first row was the owner and core of the hotel, "Aunt" Jenny Harmison. The welcoming kitchen offered free coffee to any deliveryman or local person who walked in.

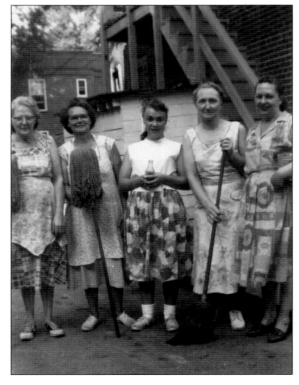

Teams of industrious local women were the secret of the Park View Inn's long success. This group of housekeeping and kitchen workers gathered behind the hotel in 1961. Mary Cain (second from right) was an institution at the Inn.

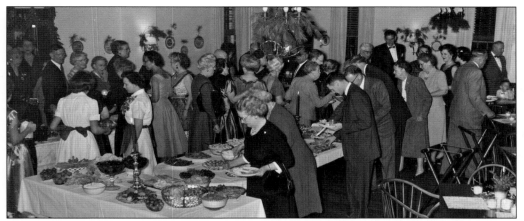

The Park View Inn's annual Christmas night supper party (pictured in 1955) served 200 guests and local notables. Preparations for the holiday took all month, including cooking and decorating some 20 trees.

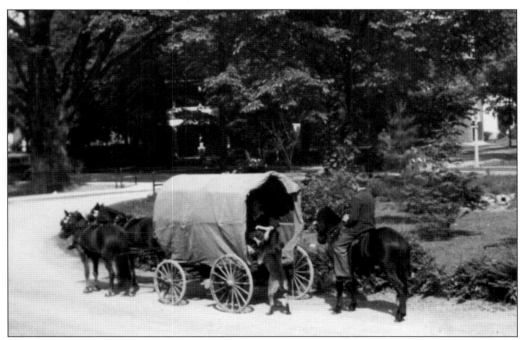

Charlie Miller made this rig for his son Foster in 1936 and used it to take guests of the Park View Inn for jaunts through town.

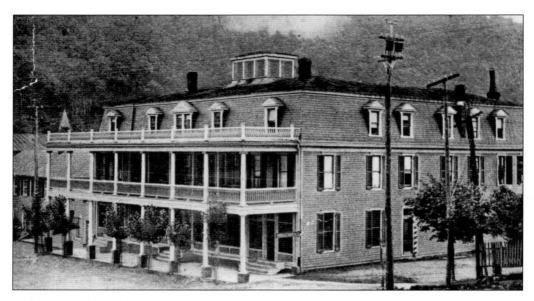

Seeking to replicate the experience of the town's former grand hotels, local businessman Daniel Dunn built his namesake hotel on the corner of Fairfax and Mercer Streets, where Harmison livery once stood. Designed by Martinsburg architect George Whitson, the Dunn Hotel opened in 1903. It was badly damaged by an arsonist's fire in 1935 and razed by 1938. In the early years, the front desk was staffed by Mr. and Mrs. Daniel Dunn and Walter "Toad" Harmison, the clerk. In 1919, the Harmison brothers took over management.

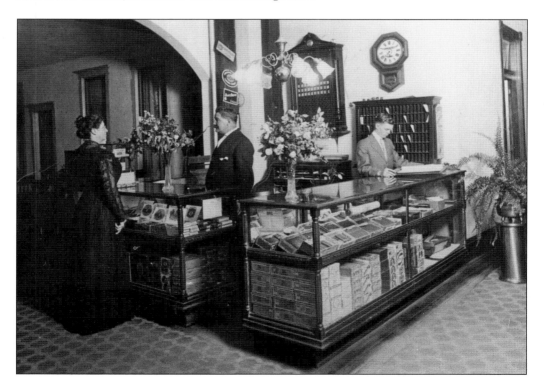

Eight

TOWN LIFE

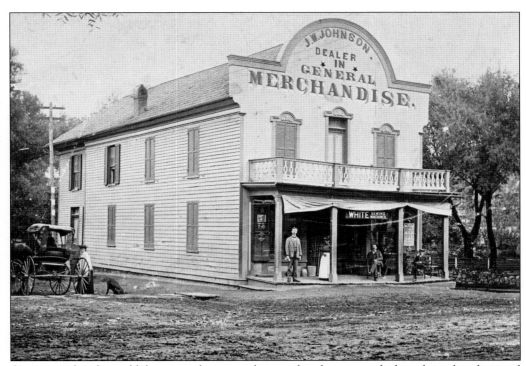

Commercial and social life in town became substantial and year-round when the railroad arrived in the region in the 1840s. Country folk made occasional visits for court business or to buy and sell. Built in 1875, this retail structure on an unpaved Washington Street still retains its distinctive rounded parapet false front. By 1890, J.W. Johnson opened a dry goods store here. Over the years, a succession of businesses followed.

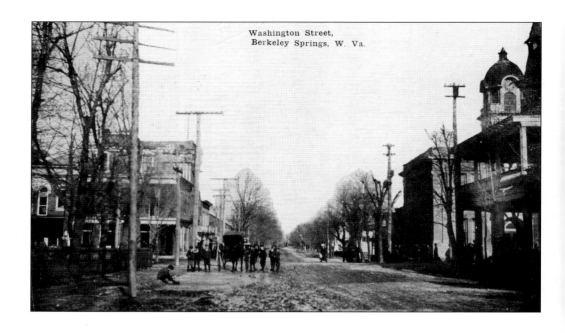

Washington Street,
Berkeley Springs, W. Va.

Pictured are two views, looking north, of the town's main intersection of Washington and Fairfax Streets. Moving clockwise from top right, the corners are filled by the courthouse, the Washington Hotel, the park entrance, and the Biser building. The image above is from around 1910; the image below is from the 1930s and features Harvey Beeler's Esso station.

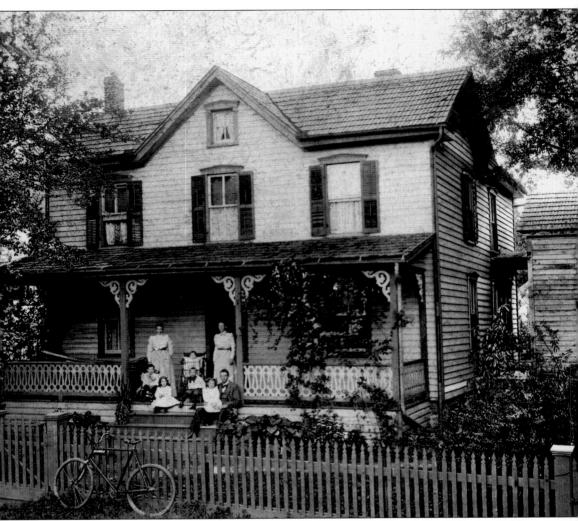

The home of newspaper owner S.S. Buzzerd was typical of local houses in town at the turn of the 20th century. It is located just west of the Episcopal church. Bicycles were the modern in-town mode of transportation. Fences surrounded homes to protect against cows and pigs roaming the streets. (Courtesy of Buzzerd collection.)

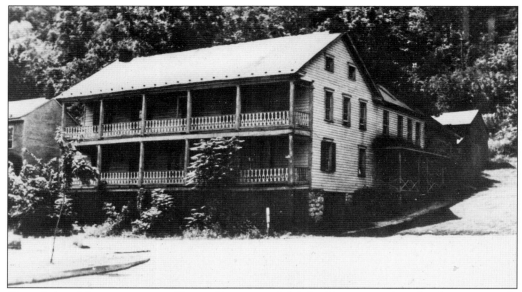

One of the oldest structures still standing, part of this building was a boardinghouse as early as 1775. Soon after, it was operated as a hotel and casino. In 1844, it was the Gault House and served as the temporary location for court meetings between the first courthouse burning and the construction of the second. Wilkes Street, on which it is located, was the main thoroughfare in town until the mid-20th century. (Courtesy of Jessie Hunter.)

Judge William Dole, an official in Abraham Lincoln's administration, directed workers in 1868 as they dug a foundation for his cottage. They razed a house on George Washington's lots on the corner of Mercer and Fairfax Streets. Dole's cottage was razed, in turn, in 1952.

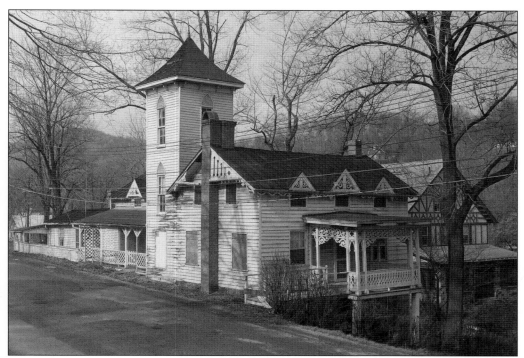

James Mercer built the core of his cottage, Tanglewood, before the town was formed. His friend George Washington stayed there. In 1848, David Hunter Strother's father presented Tanglewood to him as a wedding present, and Strother's friend Washington Irving visited in July 1853. The tower was added by Henry Harrison Hunter in 1878.

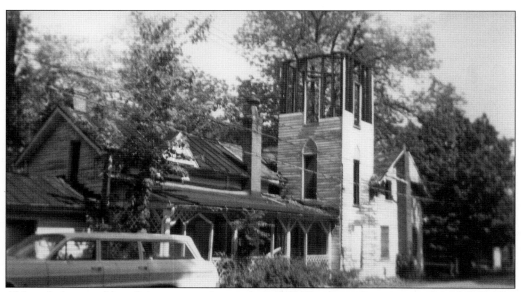

Although threats of demolition were made as early as 1902, Tanglewood was not razed until 1968. The intervening years found it home to many young married couples. One woman scandalized the town by hanging her black lingerie on the railings. It was on the corner of Bath and Mercer Streets.

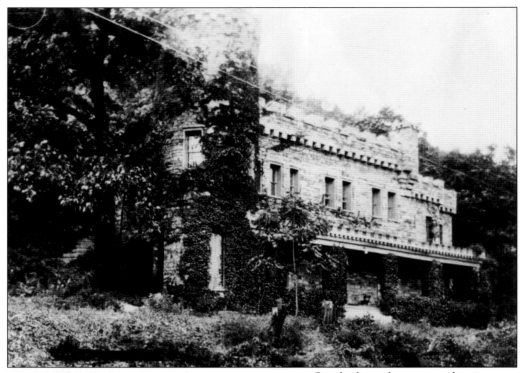

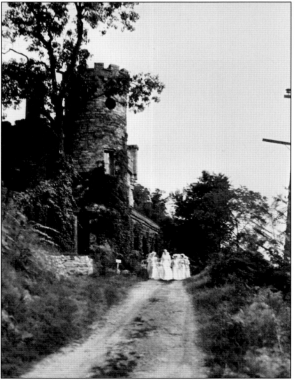

Overlooking the town and springs, Berkeley Castle was constructed in 1885 and was the prize of the Victorian cottage-building boom. By 1906 (above), it was beginning a cycle of many owners, during which it was allowed to deteriorate. In 1937 (left), the Tomato Festival queen and her court were based there. From 1950 through 2000, it was open for house tours. Today, it has been restored to its original splendor and serves as a private home.

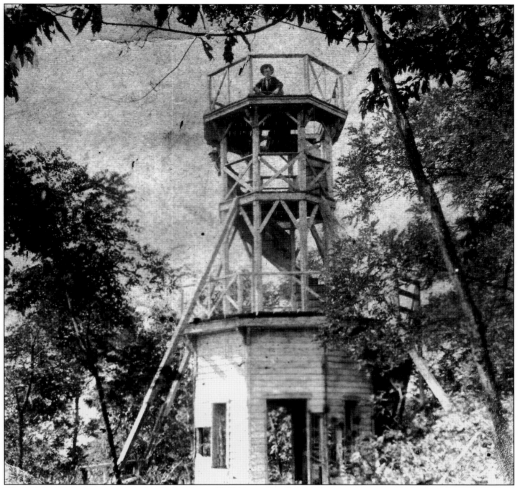

The observatory tower was built on Fruit Hill Farm land atop Warm Springs Ridge in 1880 and later destroyed by fire following Fourth of July fireworks. There were two paths to the tower—one up the mountain and the other through the park. John Moray took his famous overlook photographs of town from here in the 1880s. It was a favorite Sunday afternoon walk for locals and summer guests, although a failure as an investment.

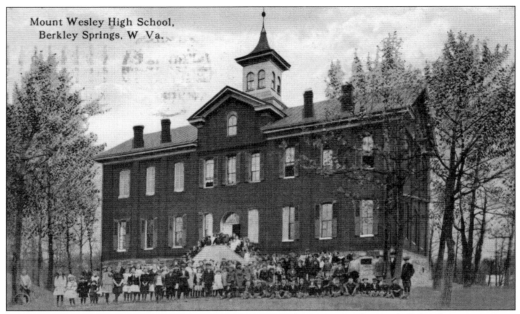

Noted local builder Henry Harrison Hunter constructed Mount Wesley High School on an eastern hillside in 1878. By 1892, it expanded to six rooms. The building was razed in 1950.

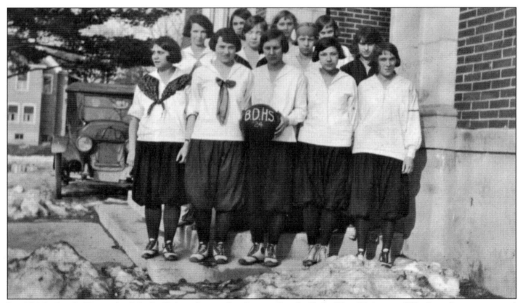

In 1921, Bath District High School was built on the ball field of Mount Wesley. It continued to serve until Berkeley Springs High School was constructed south of town between 1939 and 1940. Located on Green Street, it is used today as a community services building. (Courtesy of Buzzerd collection.)

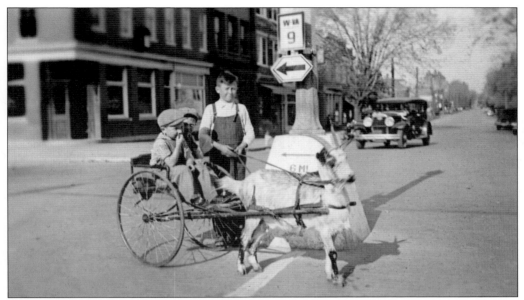

Cart rides with McCaffry's goat and its young driver were a popular diversion for town children in the mid-1930s. Pictured above is the main intersection of Washington and Fairfax Streets, with the sign mounted on a traffic dummy. Pictured below is young Bob Hawvermale as a passenger on Washington Street in front of his aunt's Park View Inn.

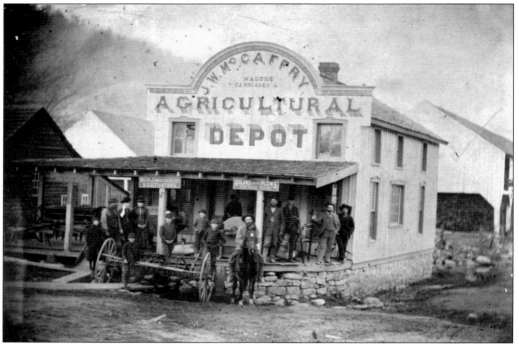

McCaffry's depot was built around 1883 on the corner of Congress and Mercer Streets. It later housed an undertaking business and then the Blue Goose Saloon. The Blue Goose was razed in 1963. North of it was a livery that was razed to construct the cold-storage facility in 1911.

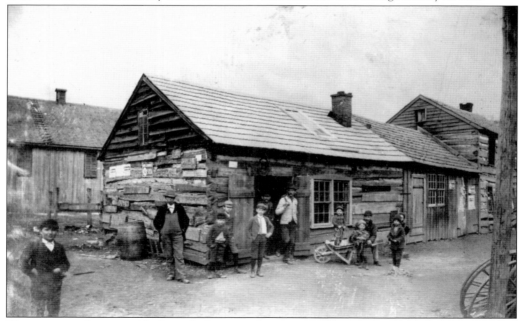

There were at least two blacksmith shops on the corners of Mercer and Independence Streets around 1900, including this one owned by C.C. Dyche. Local history holds that the adjacent log structure to the right was associated with the black community.

The feed building in the foreground was moved across Mercer Street in 1930 and is still standing. The image was shot looking north on Mercer Street during the 1920s. The train tracks continued on to the cold-storage facility. (Courtesy of Morgan Messenger.)

The livery on the corner of Mercer and Fairfax Streets changed hands repeatedly during the closing decades of the 19th century. Owners included C.P. Jack, Jacob Horn, and William Harmison. The coach that brought travelers back and forth from the train station was based here. It was razed in 1902 to build the Dunn Hotel.

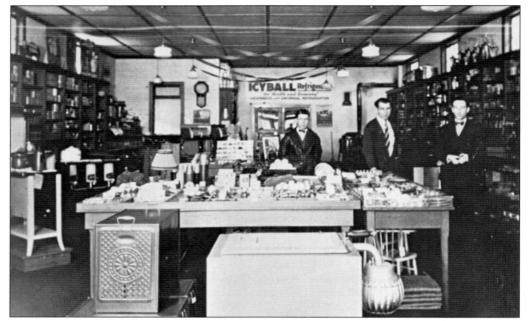

Hunter's Hardware, started as a harness shop in 1870 by Romanus Hunter, moved across Independence Street into this newly constructed building in 1928 and expanded to a full-inventory hardware store. Tom Barney (center) retired after working in the store for 70 years. In 2000, the family business was sold to longtime employees. (Courtesy of Hunter's Hardware.)

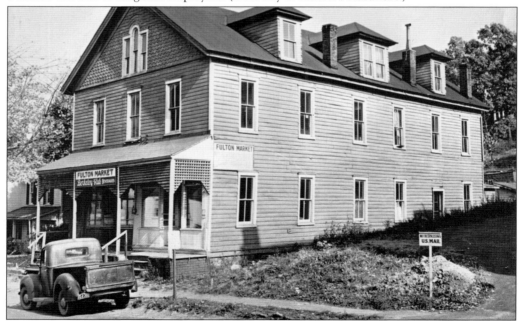

Built in 1894, Trimble Hall hosted everything from oyster suppers to vaudeville. Soon after opening, an 1895 advertisement claimed that "for best beer and lunches go to Trimbles." It served as Fulton Market in the late 1940s but was razed to make way for the fire hall in 1957. (Courtesy of Morgan Messenger.)

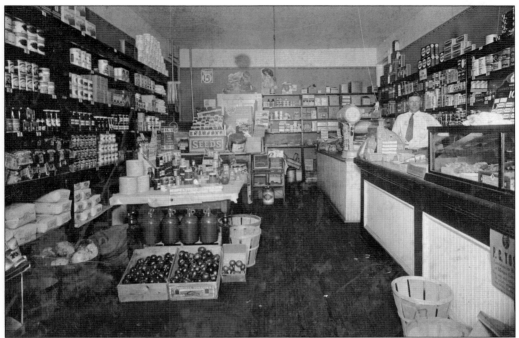

Neighborhood groceries were a fixture on virtually every block in the 1930s and 1940s. They offered credit to their customers and a bag of candy when the monthly bill was paid. Pictured above is Ayers Grocery on Fairfax Street. Ambrose & Kesecker Grocery Store was next to the courthouse on Washington Street. (Above, courtesy of Bob Ayers; below, courtesy of J. Philip Kesecker.)

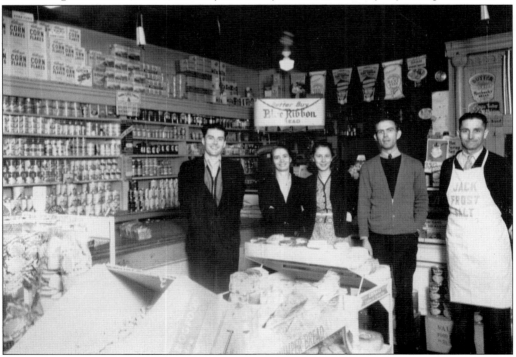

On November 12, 1970, Nobel Prize–winning author Pearl Buck stopped for an impromptu lunch at the Park View Inn. She was traveling the state, raising money to develop her birthplace in Hillsboro. Grande dames Eleanor Pendleton Campbell and Mary Dyche Hunter sat at her table. (Courtesy of Buzzerd collection.)

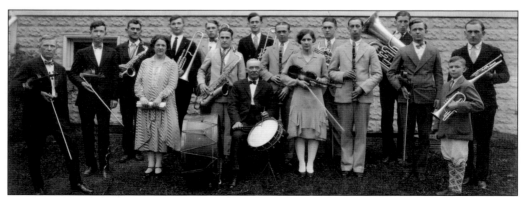

Harkening back to the many city bands a generation and two earlier, Sam Harmison had a musical group in the 1920s. It included his wife and son among its members. Reid Johnson, who later became head masseur at Berkeley Springs State Park, was in the horn section.

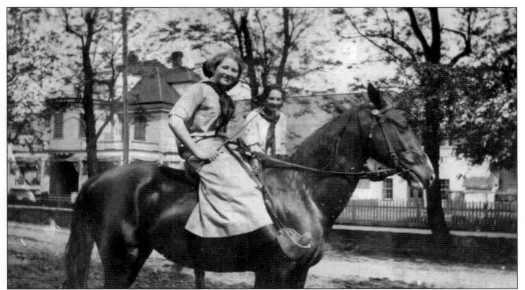

Girls ride horses on a dirt Washington Street in this c. 1915 photograph. Behind them is the distinctive rounded turret of a house that was once—and is currently—used as a public lodging place. (Courtesy of McBee family.)

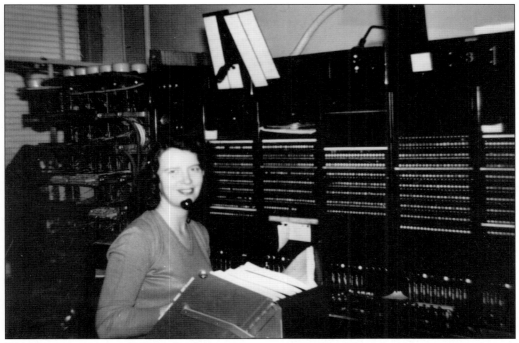

The front room was added to the former car garage in 1928 when it became a movie theater, operating continuously to the present. The town telephone switchboard moved here in 1937, where it remained for 30 years under the direction of Ruth "Sister" Miller. Jean Ditto Hughes is pictured around 1955. Today, the front room is where popcorn and candy are sold for the STAR Theatre. (Courtesy of STAR Theatre.)

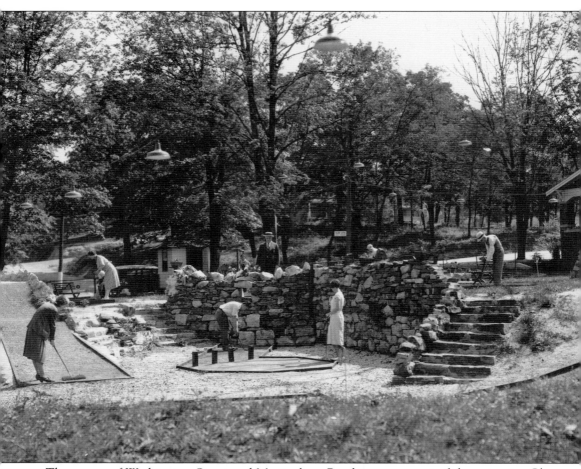

The corner of Washington Street and Martinsburg Road was once part of the extensive Glen Luta estate of Eugene Van Rensselaer. In 1930, more than a decade after the mansion was razed, Walter Harmison built an 18-hole miniature golf course, which closed the following year. It had lights for night playing. There were several other short-lived miniature golf ventures in town at the same time.

Nine

AROUND AND ABOUT

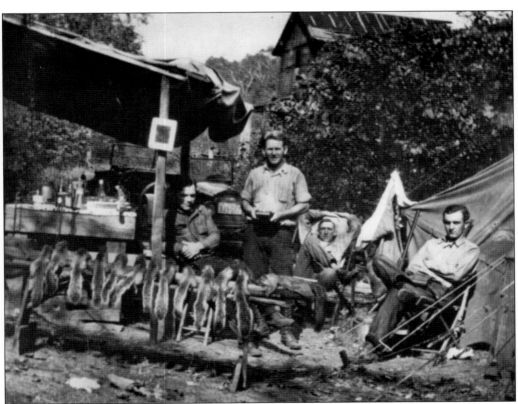

From summer camps along either the Potomac or the Cacapon Rivers to the dammed lake of Cacapon State Park, recreational activities had a strong pull on town dwellers and visitors alike. In 1924, a party that included several local businessmen spent a week at a hunting camp in the mountains harvesting squirrel. (Courtesy of Morgan Messenger.)

Summer vacations for the Buzzerd family, owners of the local newspaper, meant camping trips "up along the Cacapon River or 'Creek,' as we always called it," wrote James Buzzerd years later. They loaded camping equipment on a horse-drawn wagon that was followed by a surrey in which the mother and children rode. They would tent for two or three weeks at a time, one of the first in the area to do so for recreation. (Courtesy of Buzzerd collection.)

Nearly half a century after it happened in 1900, S.S. Buzzerd wrote about his first camping and fishing trip: "We pitched camp at the Ziler springs where the pure, cold mountain water empties into Cacapon Creek. We had no tent, so for a shelter, we carried boards from what was at one time a sawmill nearby. The hastily built shelter, being poorly constructed and with the weight of hammocks in which we tried to sleep, fell down on us early one morning. Fortunately, no one was hurt; also fortunately, it did not rain while we were there." (Both courtesy of Buzzerd collection.)

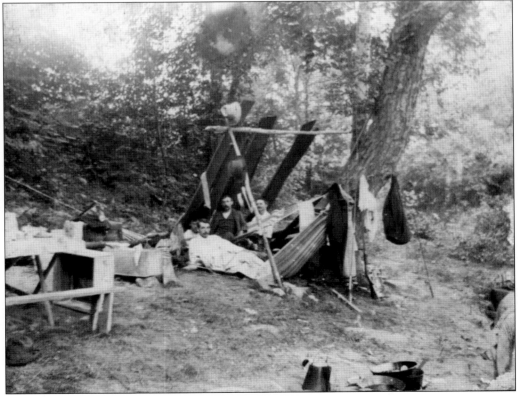

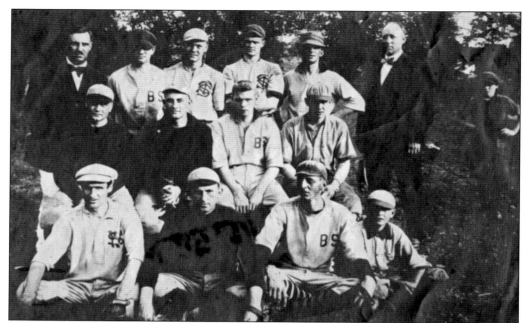

The early decades of the 20th century marked a high point for local baseball. In 1905, a news editor remarked, "The only live thing in Berkeley this summer is the baseball crowd." Team rosters shifted from season to season, and occasionally, "ball players," such as Eddie Carroll (pictured in this 1915 image, second from left, first row), showed up and stayed. Games were played on the old tournament grounds, now the campus of Berkeley Springs High School. (Courtesy of McBee family.)

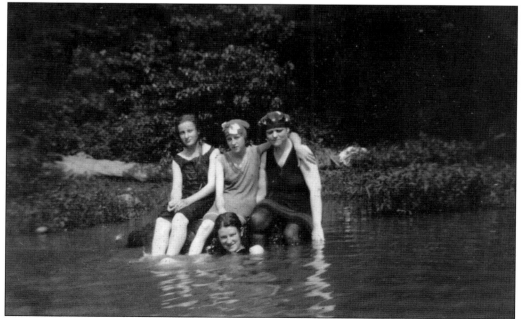

Swimming in the Potomac at various family-owned camps was a favorite summertime activity. (Courtesy of MCHS.)

Walter Harmison took 30 guests of the Park View Inn to a "mountain party" in 1939 at Jake Puffenberger's in an isolated part of the county. The program was confined to mountain folklore and included music. Jake talked about the hunting and trapping of wild game, a major source of livelihood during winter. Extolling their simplicity and homely virtue, a guest dubbed Jake and his wife "Knight of the Mountain and Queen of the Hills."

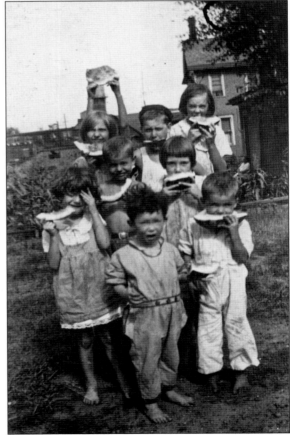

For country kids, eating watermelon from the garden was a high point of summer. (Courtesy of Andrea Adams.)

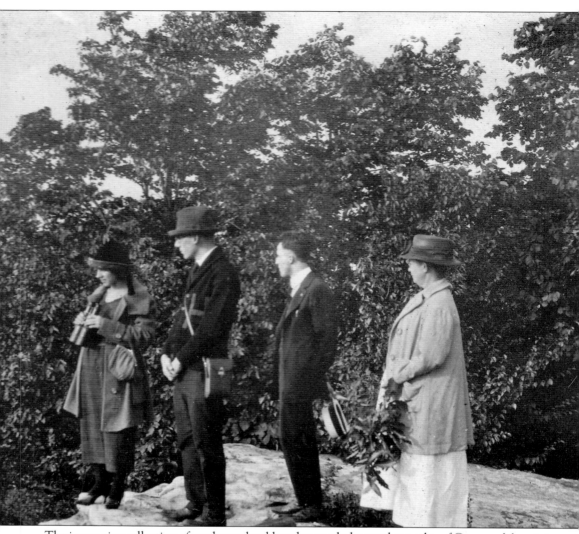

The impressive collection of sandstone boulders that mark the northern edge of Cacapon Mountain before it begins its plunge into the Potomac River has been a favorite excursion since George Washington rode there on his 18th-century visits. The view is northwest, overlooking the Cacapon River. Prospect Rocks were the geologic treasure that motivated the formation of Cacapon State Park in the 1930s, about 20 years after this photograph was taken. (Courtesy of MCHS.)

The new road went from Berkeley Springs over the mountain to Great Cacapon in 1924, creating an easy drive to the still popular Panorama Overlook. (Courtesy of MCHS.)

A rough road that had been used for hauling bark on top of Cacapon Mountain was repaired by private subscription, making it easy (in 1920s terms) to reach Prospect Rocks in any vehicle. (Courtesy of MCHS.)

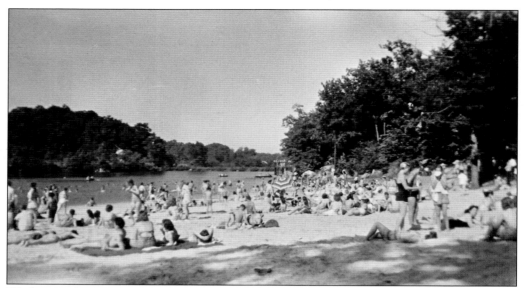

Work started on Cacapon State Park in 1934, and it opened three years later. Cacapon was a Civilian Conservation Corps project that included a lodge, cabins, and the lake. The 25-foot-deep lake was formed by damming Indian Run. Originally, sand for the beach was hauled from a pure vein in nearby Rock Gap.

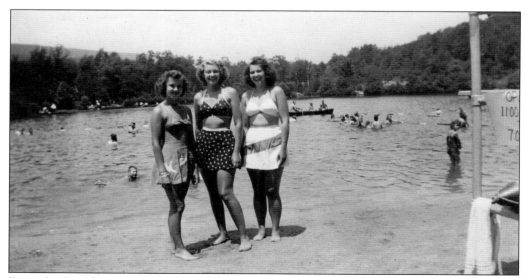

From the first day it opened, the lake at Cacapon State Park has been a local favorite. In the 1940s, (from left to right) Eloise (Buckwheat) Lutman, Else ?, and Margi Carroll soaked up the sun on the beach. (Courtesy of McBee family.)

The Dawson family lived in the county near Cacapon State Park, and the cousins often enjoyed Sunday picnics there. The kids are, from left to right, Medford, Bonnie, and Kenda Dawson; Sylvia Dawson is holding baby Cheryl Henry; and the rest of the children were also Henrys—Ray, Robert, and Larry. (Courtesy of Sylvia Dawson Thomas.)

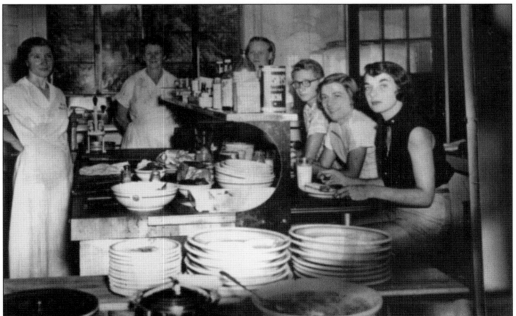

The restaurant at Cacapon State Park aimed to serve good country food. It provided employment for many local people. The 1950s, kitchen staff included a young, spectacled Raymond Lawyer (a future bank official) and next to him, the superintendent's wife, Teenie Long Dawson (second from right). (Courtesy of Tom Ambrose.)

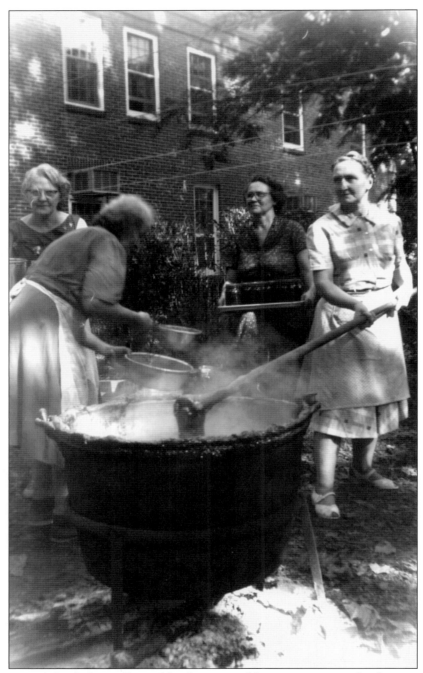

The 21st-century Apple Butter Festival has long roots. Newspapers wrote of making apple butter and "pulling together" as early as 1903. Kitchen staff at the Park View Inn made upwards of 100 gallons annually and served it in the dining room all through the year. On Christmas morning, every guest received a jar in red and green tissue paper. Like today's festival, sometimes guests would give a stir. Pictured behind the inn are, from left to right, Minnie Penner, Mary Frederick (back to the camera), Bessie Stotler, and Mary Cain.

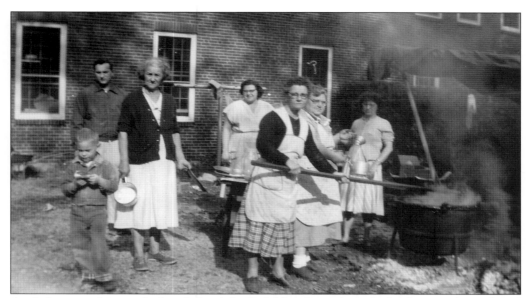

Apple butter making took place behind the Park View Inn, where the kitchen was located, and used local apples. In the mid-1950s, young Billy and his father, Bill Harmison, joined the kitchen staff to make butter.

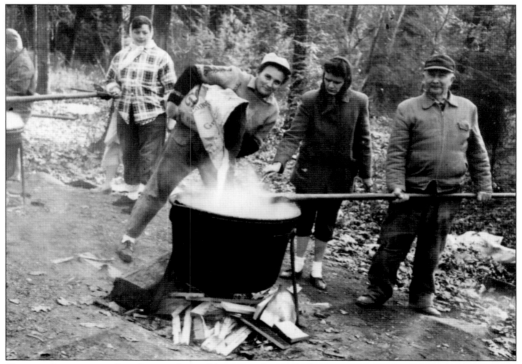

Out in the county, families and neighbors made apple butter to store for the winter. Pouring in the sugar—traditional recipes call for a pound per gallon—is known as "adding the money." Gladys Butts anchored this group in Spruce Pine Hollow in the 1950s. (Courtesy of Gladys Butts family.)

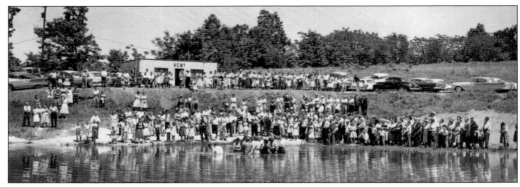

An early-1960s mass baptism in the pond at the local radio station, then with the call letters WCST, was a result of the preaching of guitar-playing and singing Rev. Raymond Jones. One resident reported that everyone in town listened on Saturday morning to Reverend Jones and his theme song, "Are You Traveling Down the Road of Prayer?" (Courtesy of Virgil Ruppenthal.)

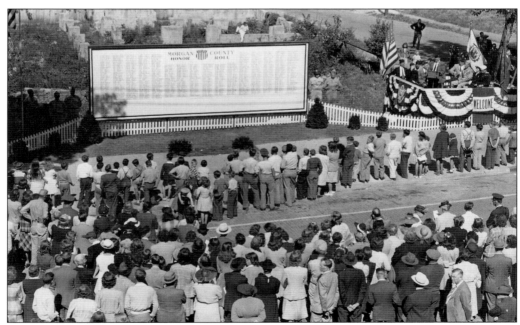

A temporary billboard listing the honor roll of World War II veterans was erected on the corner lot at Fairfax and Mercer Streets. The ruins of the Dunn Hotel remain in the background.

Up against a scheduled official dedication, Pennsylvania Glass Sand provided a large sewer pipe and capped it with concrete to serve as a local time capsule for the West Virginia Centennial in 1963. Young Lisa Capen gazes admiringly at it in the park. Soon, a blue pipe with an atomic-age top replaced it, and it was removed in turn in 1996. The historical material and messages in the capsule remain safely buried in the original location without aboveground markings.

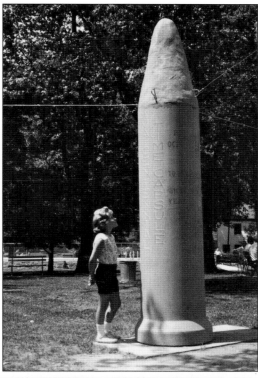

West Virginia Governor Wally Barron and other state officials joined local dignitaries and approximately 2,000 members of the public to unveil the time capsule on October 12, 1963. It was dubbed as "one of the most unique projects of the centennial year in the state."

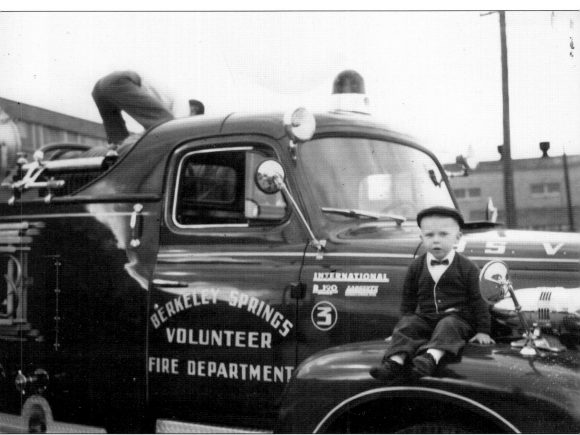

Young Mark Ayers is comfortable on the International fire truck purchased by the Berkeley Springs Volunteer Fire Department in 1957. Soon after getting the truck, the fire company was able to house it in their newly built fire hall on Mercer Street, which it still occupies today. (Courtesy of Bob Ayers.)

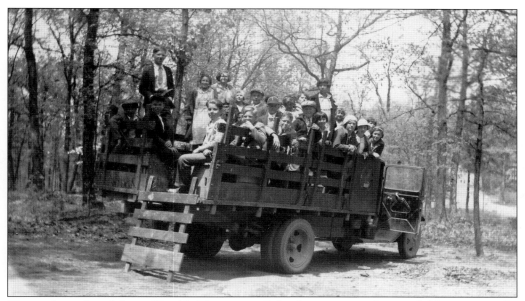

The students from Mount Trimble Elementary School set out on a history field trip to nearby Fort Frederick in May 1934. (Courtesy of Gladys Butts family.)

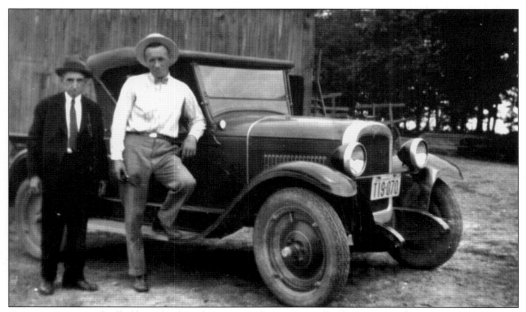

George Hovermale (left) and Theodore Eversol pose proudly with their 1927 Chevrolet on the Hovermale farm. (Courtesy of Julian Hovermale.)

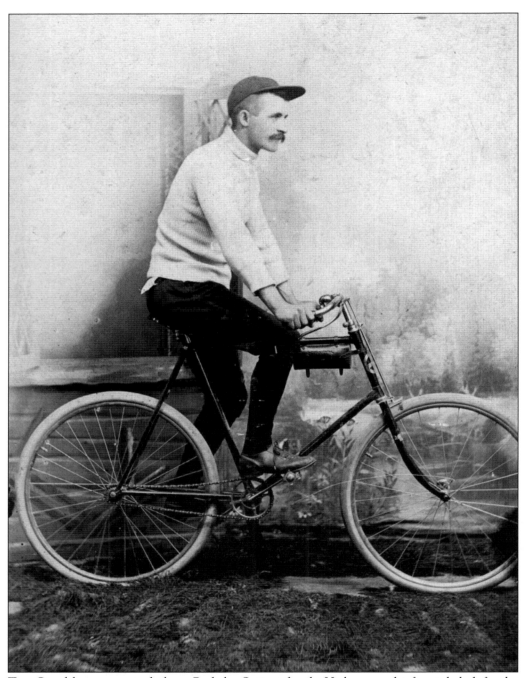

Tom Coughlan was part of a large Berkeley Springs family. He became chief postal clerk for the B&O Railroad. His family owned Coughlan Drugs and printed postcards of the area that are used throughout this book. The invention of the safety bicycle in 1885 made it a popular means of transportation for town dwellers for the next 30 years. (Courtesy of McBee family.)

Ten

PEOPLE

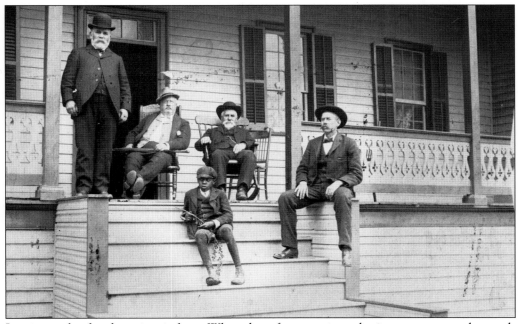

Iconic people often have iconic faces. When these four prominent businessmen sat on the porch of the Flagg House in 1900, it was still the original structure built as an inn in 1779. George Washington spent a night there in 1794 while it was owned by John Hunter, whose great-grandson Romanus Hunter is the man standing in this image. Moving right, there is N.S.D. Pendleton, Dan Cornelius, and George Ziler. Moses Brown is the errand boy seated on the steps.

From the discovery and development of the sand industry to designing the Victorian-era covered bathhouses, Henry Harrison Hunter ("H.H." or "Tip") was the most accomplished native of Berkeley Springs. Born in 1840, he was a Confederate soldier, spy, and scout, as well as a prospector, inventor, and self-taught architect. The local sand he personally mined, pulverized, and exhibited won a blue ribbon at the 1893 Chicago Exposition.

The Hunter family included two generations that designed and constructed virtually every important 19th-century structure still standing, including the Episcopal and Presbyterian churches. Pictured above are H.H. (left) and his nephew Charles around 1900. Pictured below are brothers John (left) and Charles Hunter. (Above, courtesy of Jessie Hunter; below, courtesy of MCHS.)

William Mesner is the man leaning on his cane with the Washington Hotel in the background in this c. 1910 photograph. (Courtesy of MCHS.)

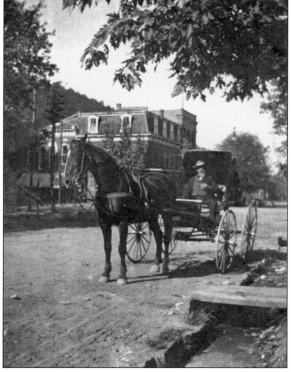

During the 1880s, 1890s, and into the 20th century, Dan Cornelius was a sharp businessman and developer involved in various projects, including Fruit Hill Farm and the Berkeley Springs Hotel. He bought the St. Charles, renamed it the Fairfax Inn, and turned it into a lively night spot. He was the owner when it burned in 1901. (Courtesy of Jessie Hunter.)

Successful Maryland businessman Samuel Suit married Rosa Pelham, daughter of an Alabama congressman, in 1883. He was 53, and she was 22. Two years later, he built her a summer cottage that was soon known as Berkeley Castle. Suit was dead in 1888, and Rosa proceeded to party his money—and eventually his castle—away.

In 1953, Sally Horn wrote glamorized, and occasionally fanciful, booklets on the history and great houses of Berkeley Springs. Her parents divorced in the late 1890s, and she lived with her mother, never marrying. (Courtesy of McBee family.)

John Casler fought in the Spanish-American War. His name is engraved on the Veterans Memorial on Fairfax Street. (Courtesy of McBee family.)

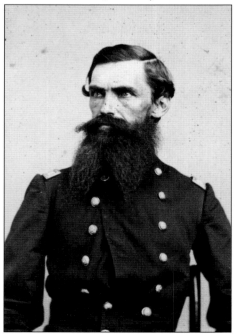

A *carte-de-visite* photograph by Matthew Brady shows one of Berkeley Springs' most illustrious residents. David Hunter Strother served actively as a staff officer in the Union army. He was later appointed consul general of Mexico. He inherited and operated the Berkeley Springs Hotel. Known as Porte Crayon, he was the most noted illustrator and travel writer of his era. (Courtesy of Ed Steers.)

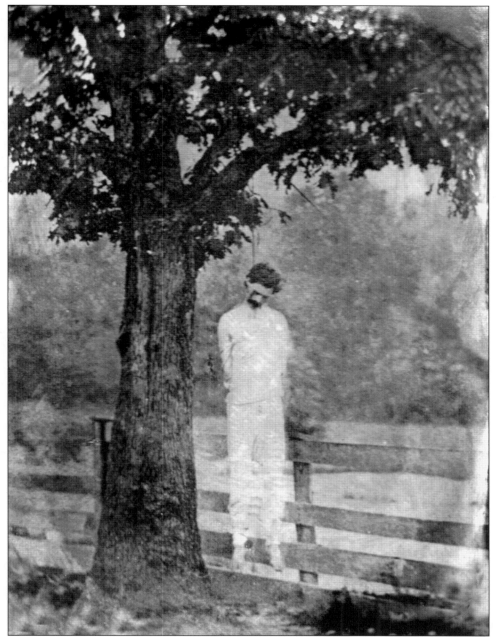

Berkeley Springs' only lynching took place on August 24, 1876, on the southern boundary of town. Dr. Samuel Crawford, a country doctor, was accused of poisoning a man but never put on trial. A mob intervened, taking him from the local jail and unlawfully hanging him. One version claims Crawford an innocent man and that no traces of poison were found. Another blackens him as gambler, horse thief, and ladies' man. Most likely, he matched both descriptions and a carpetbagger from up north who ran afoul of southern regulators and county officials. He was buried in the Dutch/German Cemetery, where workmen later reported seeing his ghost. (Courtesy of Buzzerd collection.)

www.arcadiapublishing.com

Discover books about the town where you grew up, the cities where your friends and families live, the town where your parents met, or even that retirement spot you've been dreaming about. Our Web site provides history lovers with exclusive deals, advanced notification about new titles, e-mail alerts of author events, and much more.

MADE IN THE USA

Arcadia Publishing, the leading local history publisher in the United States, is committed to making history accessible and meaningful through publishing books that celebrate and preserve the heritage of America's people and places. Consistent with our mission to preserve history on a local level, this book was printed in South Carolina on American-made paper and manufactured entirely in the United States.

This book carries the accredited Forest Stewardship Council (FSC) label and is printed on 100 percent FSC-certified paper. Products carrying the FSC label are independently certified to assure consumers that they come from forests that are managed to meet the social, economic, and ecological needs of present and future generations.

FSC
Mixed Sources
Product group from well-managed forests and other controlled sources

Cert no. SW-COC-001530
www.fsc.org
© 1996 Forest Stewardship Council

Find Your Place in History.